944690

HOW TO DRAW AND SELL...

COMIC STRIPS

...FOR NEWSPAPERS AND COMIC BOOKS!

# HOW TO DRAW AND SELL...
# COMIC STRIPS
# ...FOR NEWSPAPERS AND COMIC BOOKS!

## Alan McKenzie

NORTH LIGHT BOOKS

Cincinnati, Ohio

A QUARTO BOOK

First published in the U.S.A. by
North Light Books, an imprint of
F & W Publications, Inc.
1507 Dana Avenue
Cincinnati, Ohio 45207

Reprinted 1991, 1993

Library of Congress Cataloging-in-Publication Data
McKenzie, Alan.
How to draw and sell comic strips.
Bibliography: P.
Includes index.
1. Comic books, strips, etc. – Illustrations
2. Comic books, strips, etc. – Marketing. 3. Drawing –
Technique. I. Title.
NC1764.M34   1987   741.5   87-14134
ISBN 0-89134-214-1

This book was designed and produced by
Quarto Publishing plc
The Old Brewery, 6 Blundell Street
London N7 9BH

**SENIOR EDITOR** Polly Powell
**ART EDITOR** Vincent Murphy

**EDITOR** Paul Barnett
**ASSISTANT EDITOR** Joanna Bradshaw

**DESIGNER** Dave Whelan

**ILLUSTRATORS** Steve Parkhouse, Rodney Sutton,
Ross Thompson
**PHOTOGRAPHER** David Evans
**PICTURE RESEARCHER** Penny Grant
**PASTE-UP** Mick Hill, Patrizio Semproni
Many thanks to Declan Considine

**ART DIRECTOR:** Moira Clinch
**EDITORIAL DIRECTOR:** Carolyn King

Typeset by Text Filmsetters and Comproom Ltd
Manufactured in Hong Kong by Regent Publishing Services Ltd
Printed by Leefung-Asco Printers Ltd, Hong Kong

# CONTENTS

Foreword 7
by Sydney Jordan

## PART 1

### INTRODUCTION

## PART 2

### MASTERING THE COMIC STRIP

## PART 3

### SELLING YOUR WORK

ALAN McKENZIE
BY STEVE PARKHOUSE

# FOREWORD

It would be all too easy for me to say that had a book like *How to Draw and Sell Comic Strips* been available when I began my career as a comic strip artist I would have avoided many or all of the pitfalls which litter one's early days – and that would certainly be true. But I had the great good fortune to be working and learning during what, in retrospect, was surely the "golden age" of British newspaper strips; that halcyon period between the middle fifties and late sixties when most of the popular papers boasted a fully staffed strip department and the press barons themselves were known to keep an eye on content and quality!

What makes Alan McKenzie's book so timely is that now, in the eighties, those who wish to "draw comics" must do so in a creative and highly competitive climate. The informed patronage which my contemporaries and I enjoyed has gone from all but the most enlightened publishing sectors, and the fight for a permanent place in the sun must now encompass not only a mastery over the medium but also a knowledge of those markets most likely to encourage and reward the dedicated artist. The serious student of comic art will recognize that a lifetime career cannot be built on the shifting sands of contemporary marketing, but needs a solid foundation. The author provides such a base, within the confines of this book, assembling as he has an extraordinary amount of relevant information and examples of some of the best comic artwork ever produced.

As someone whose working life has been spent in the production of comic strips, I can confirm without hesitation that Alan McKenzie tells it like it is.

*Sydney Jordan*

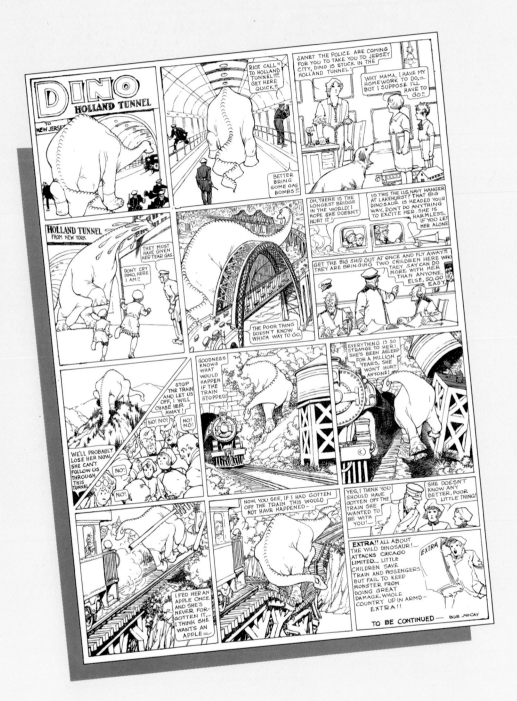

# PART 1 INTRODUCTION

**A History of Comics**
Early newspaper strips ★ The Yellow Kid ★ The syndicates arrive ★
Comics go it alone ★ Giants of the newspaper strip ★ Comic books get
creative ★ Pioneering spirit ★ "Gasp! Choke! It's E.C." ★ A comics Marvel ★
The fandom revolution

**Comics Around the World**
The United States ★ The United Kingdom ★ France and Belgium ★ Italy ★
Germany ★ The Far East

# A History of Comics

Accurately to chronicle the 90-year life of the comic strip would take up a whole book in itself. And to do such a story justice, that book would need to be two or three times as long as this one. All we have room for here is a whistle-stop tour through those 90 years to give the reader a better idea of how the art of the comic has changed over the decades.

### Early newspaper strips

The earliest appearance of the comic strip as we know it was in the pages of the big US newspapers at the turn of the century. Gag panels (as they used to call one-picture cartoons) and political cartoons had been around for some time, so the idea of communicating ideas in a two-dimensional picture form was not a new one. But in 1894, when the *continuity* strip first appeared, a whole new dimension was added to cartooning: *time*. By presenting a sequence of pictures, an artist could put across the illusion of a series of events in chronological order. This naturally led to the addition of an important ingredient, previously possible only in the live performance of an actor or comedian: *timing*.

This advance was so influential that the creators spent the first 30 years of comic strips exploring only their possibilities for comedy, without giving a thought to the potential of comics for telling dramatic tales. It is for this reason that the term "comic strips" came to be applied to all continuity art, whether the strip in question was comic or dramatic.

Unlike the cinema, to which comics are closely related, the comic strip matured slowly. Although the earliest films were made and screened for their novelty value, within a few years sophisticated creative talents such as D. W. Griffith were pushing at the frontiers of the artform, peaking with films such as *The Birth of a Nation* (1915) and *Intolerance* (1916). Over in the comics camp, however, the levels of artistry would not catch up with those of the cinema until the advent of Hal Foster's *Tarzan* (1929) and Alex Raymond's *Flash Gordon* (1934) newspaper strips.

Comparisons between comics and cinema are inevitable. Both use words and sequential pictures to tell a story. Both borrow each other's ideas, with or without acknowledgement. Indeed, these days it is fashionable – and very much the comic-industry norm – to describe comics in cinematic terms. However, it should be stressed that the comics came on the scene several years before the movies.

As with all new artforms, the earliest comics were crude affairs, lacking in any real writing or drawing skill. And, heaping insult upon injury, comics were not even regarded as a worthwhile endeavor for their own sake. They were regarded as nothing more than circulation-boosters for the newspapers in which they appeared. Indeed, so low did the comic come in importance that the earliest efforts were not even subject to the copyright laws.

### The Yellow Kid

The first time this problem came up was with the first regular comic strip of all, *Down Hogan's Alley* by Richard Outcault, which debuted in 1895 and featured a character called The Yellow Kid. Both this strip and *The Origin of a New Species*,

**Above:** A panel from Winsor McCay's only known comic strip of the character *Dino the Dinosaur,* drawn in 1909. Even in this small example, McCay's ability to suggest scale is apparent.

also by Outcault, which had appeared a year earlier, were published in the *New York World*, a paper owned by the famous news magnate Joseph Pulitzer. By 1896, The Yellow Kid had moved up to take over the lead of Outcault's strip. At the same time, Pulitzer's chief rival William Hearst had hired most of the staff of the *World*, including Outcault, to work on his own paper, the *New York Journal*. Outcault simply took his character with him to the *Journal*, while Pulitzer hired another artist, George Luks, to draw The Yellow Kid for the *World*. Thus, The Yellow Kid was running in two rival papers simultaneously. There was simply no precedent in law to determine exactly who owned the copyright on the character.

The problem came up again with a strip called *The Katzenjammer Kids* by Rudolph Dirks. The strip made its first appearance in Hearst's *Journal* in 1896. When Dirks finally left the paper, he took the *Kids* with him. Hearst decided enough was too much and called in the lawyers. The case reached court in 1912 and the judgement handed down set a precedent that seems not to have been adhered to. Hearst was granted the right to the title, *The Katzenjammer Kids*, and so he hired a new artist, Harold Knerr, to continue the strip. But Dirks was permitted to continue the same characters under a new title, *The Captain and the Kids*.

In the years that followed the inauguration of *The Katzenjammer Kids*, other artists began to get in on the comic act. Frederick Opper introduced three strips, *Happy Hooligan*, *And Her Name was Maud* and *Alphonse and Gaston*. Outcault struck again with *Buster Brown*, and a cartoonist called George Herriman, who was to go on to greater things, had his first published strip in *Lariat Pete*.

But so far all these offerings had been confined to the color comics sections which appeared only in the Sunday editions of newspapers. It was not until 1904 that the first daily strip appeared – *A. Piker Clerk*, by Clare Briggs. In the same

year, some newspapers began to sell collections in comic-book form of their Sunday strips, such as *The Katzenjammer Kids* and *Happy Hooligan*, for the then high price of 75 cents.

The following year saw the debuts of a whole slew of comic strips, most of them forgotten today. The only one that really stood out was *Little Nemo in Slumberland*, by Winsor McCay, which was the first strip to break away from the humor tradition, introducing fantasy as a genre. McCay's artistic style on *Nemo* was a curious cross between Art Nouveau and Surrealism. Each episode told of the adventures of a little boy called Nemo after he went to sleep at night, in the region of his dreams called Slumberland.

In 1909, Bud Fisher's famous duo Mutt and Jeff received their own strip. The characters had appeared two years earlier in the *San Francisco Chronicle* in a strip called *Mr A. Mutt*. In 1910 another strip which was to make comic history appeared, initially as a footnote to George Herriman's *The Family Upstairs*. The supplementary strips featured the adventures of a cat and a mouse. This pair would eventually be awarded their own strip, *Krazy Kat*, in 1913. The premise of

**Above:** Rudolph Dirks invented and drew *The Katzenjammer Kids* for *The New York Journal* in 1896, but when he left for *The New York World* in 1910 he took the newspaper strip with him, renaming it *The Captain and the Kids*. This is a later episode by Dirks from 1940.

**Top:** *Little Sammy Sneeze,* by the great Winsor McCay (1905).
**Center:** Bud Fisher's *Mutt 'n Jeff* (1928).
**Above:** The inimitable *Krazy Kat* by George Herriman (1928).

*Krazy Kat* was that the cat, Krazy, loves the mouse, Ignatz. The mouse throws bricks at the cat's head in an effort to thwart the cat's attentions and ends up behind bars, courtesy of Offissa Pupp, who loves the cat. This formula was used for every *Krazy Kat* strip published. Yet, behind the constantly repeated action, the background of the strip was truly weird, ever-changing. The dialogue, too, bore little resemblance to the speech patterns of the times, and incorporated the ideals of Surrealism into its framework. Despite all this, the feature retained its popularity for decades.

In 1912, William Hearst inaugurated a concept that would revolutionize the distribution of comic strips throughout the world – the syndication agency. The International News Service existed primarily to sell reprint rights of news and

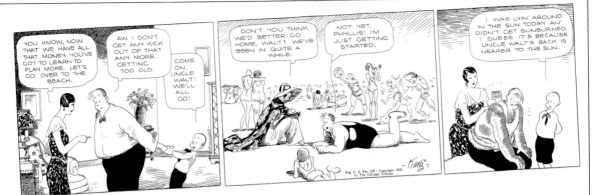

## RUPERT and the Palace Mice

Episode 7

Saying goodbye to the Guide, Rupert sets off for home with the rolled-up pattern under his arm. "I must look out for Dinkie," he murmurs, "and when I tell her about the toy cats perhaps she won't leave Beryl after all."

Rupert has not gone far when he sees the puss strolling across a woodland patch. "Hi, Dinkie!" he cries. But

the cat takes no notice. "Maybe she didn't hear me," thinks Rupert. "I'll call again, louder this time. Hey, Dinkie!"

Still the puss ignores Rupert and stalks further into the wood. "The bushes are too thick for me to go following Dinkie," says Rupert. "Oh, dear, I do wish she'd waited."

*All Rights Reserved*

**Above:** Despite an in-built blandness, *Gasoline Alley*, by Frank King, enjoyed a long run, from 1909 up to the present day. **Left:** Mary Tourtel's *Rupert the Bear* first appeared in 1920 but achieved even greater success when Alfred Bester took over in the early thirties.

features – and, of course, comic strips – from Hearst newspapers to independent newspapers in the United States as well as to publishers in other countries. The idea was a big success, and over the next few years the International News Service evolved into the King Features Syndicate, the biggest in the field, and spawned many imitators: the Chicago Tribune–Daily News Syndicate and the United Features Syndicate were among the biggest, with many smaller agencies bringing up the rear end of the list.

For the next 15 years or so, most newspaper comic strips tended toward situation comedy, of the type we suffer on TV today. While most of this comic material was pretty bland, a few offerings stood out and enjoyed long runs.

Then, in 1929, the year of the Great Depression, comics were changed forever by a series of new developments. Two new strips made their debuts and changed the accepted format of the comic strip. These were Hal Foster's beautifully drawn strip version of *Tarzan* and Dick Calkins' science-fiction series *Buck Rogers in the 25th Century*. Foster's illustrative style went some way to removing the "bigfoot" stigma which had hung over comics since their inception 35 years earlier. In fact, so popular was Foster's work that, when he left the strip several years later, King Features Syndicate, who distributed *Tarzan*, were thrown into a panic. However, their hiring of a new young artist, Burne Hogarth, proved that no one was indispensable and *Tarzan* continued, if anything more popular than before.

In 1931 another legend of the comic strip made his first bow – Dick Tracy. Written and drawn by Chester Gould, *Dick Tracy* made up for its rather poor artwork with the gritty realism of its stories. In fact, the strip came under criticism in some quarters for the brutality it displayed. Nevertheless, the series was a huge success with audiences, who thrilled to Tracy's cliffhanging adventures as he fought such bizarre menaces as The Brow, Flattop, Mumbles and Pruneface – all of whom suited their names perfectly. The idea of cliffhanging endings probably contributed greatly to the strip's success. There is even a story, probably apocryphal, that when President Franklin Roosevelt, a keen Tracy follower, was unable to stand the suspense he would call the Chicago-Tribune Syndicate to find out how Tracy was going to deal with the current cliffhanger.

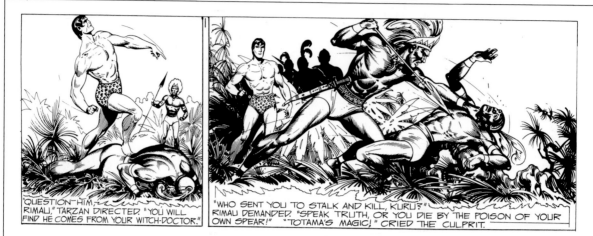

"QUESTION HIM, RIMAU," TARZAN DIRECTED. "YOU WILL FIND HE COMES FROM YOUR WITCH-DOCTOR."

"WHO SENT YOU TO STALK AND KILL, KURLI?" RIMAU DEMANDED. "SPEAK TRUTH, OR YOU DIE BY THE POISON OF YOUR OWN SPEAR!" "TOTAMA'S MAGIC!" CRIED THE CULPRIT.

**Above:** Edgar Rice Burroughs' *Tarzan* has been one of the great newspaper strip successes. It was initially drawn by Hal Foster but later taken over by Burne Hogarth, who created the definitive look for the character.

In 1929, the next stage in the evolution of the comic strip took place. A pulp-magazine publishing director called George Delacorte, who would later found the Dell Comic Company, produced a tabloid-sized color comic book called *The Funnies*. He commissioned all new material and distributed the oversized comic through newsstands with a 10-cent cover price. However, the result looked like nothing more than a Sunday comics supplement that a reader might find for free in his regular Sunday paper. Not even halving the cover price could save the ill fated project, and the experiment lasted only 13 issues. But the basic premise was sound and, a few years later, comic books re-emerged.

### Comics go it alone

By 1933, four years after Delacorte's unsuccessful *Funnies* experiment, other publishing folk were turning their thoughts to the idea of a magazine devoted entirely to comics. A man called Harry Wildenberg, who worked for the huge Eastern Color Publishing Company, figured out a way to produce a cheap comic magazine to be used as a promotional giveaway. His comic would be half the size of *The Funnies*, achieved by folding the tabloid size in half and stapling through the spine, a process called "saddle stitching," which is still in use on US comic books to this day. Thus one sheet of newspaper could be folded down to make 16 pages measuring about 8in × 11in. Four sheets of newspaper made a 64-page book, onto which a glossy cover could be stitched. That format was the norm for the US comic-book industry for 20 years. The format would accommodate a Sunday comics page reduced to half its usual size.

When Max Charles Gaines joined Eastern Color he persuaded such large companies as Proctor & Gamble and Canada Dry to use the new comic books as sales premiums. Such titles as *Funnies on Parade*, *Famous Funnies* and *Century of Comics* were born. Then Gaines, feeling that Delacorte had been onto something four years earlier, put "10¢" stickers on a few dozen copies of his comic books. Within two days, every copy had sold out.

Eastern Color knew that these comic books had a future. So they contacted Delacorte and set up a deal with him to distribute their books. As the news distribution agency, American News, refused to make a deal, Delacorte, still wary of the new-fangled invention, placed 35,000 comic books with book stores. Then he dropped out of the picture again, and Eastern managed to make a deal with American News for newsstand distribution of *Famous Funnies*.

### Giants of the newspaper strip

In 1934, King Features Syndicate, which had seemed uninterested in the new concept of adventure comics, introduced three new series, all by the same artist,

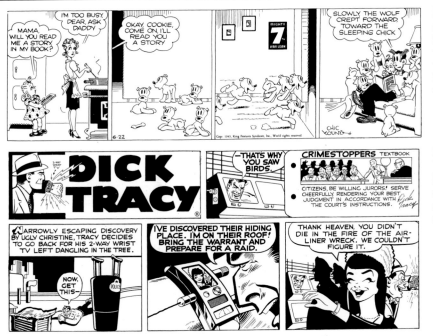

**Left:** Chic Young's *Blondie* is an American institution which has followed the life of the fair-haired flapper from her bachelor days through to family life.

**Left:** The hard-hitting *Dick Tracy* comic strip, created by Chester Gould, set the style for just about all subsequent detective comic strips.

Alex Raymond. The first of these, which Raymond both wrote and drew, was possibly the most famous space strip of all: *Flash Gordon.* This science-fiction strip had ten times the imagination of *Buck Rogers* and was a masterpiece of comic art. Raymond's imagination created a never-never land of mythic proportions on the fabulous planet of Mongo. Earthman Flash, along with his beautiful girlfriend Dale and his mentor Dr. Zharkov, teamed up with a bunch of terrorists on Mongo to fight the tyrannical rule of the despicable Ming, self-styled ruler of the Universe.

Raymond's other strips were *Secret Agent X–9*, scripted for a time by the famous mystery writer Dashiel Hammett, and *Jungle Jim*, which featured a kind of civilized Tarzan.

Also in 1934 came the mystical hero of Lee Falk's *Mandrake the Magician*, who had only to "gesture hypnotically" to make the Earth move. The art was by Phil Davis in a kind of Alex Raymond style.

A far bigger hit was Milton Caniff's *Terry and the Pirates* (1934). The hero was a young boy who, with his unofficial guardian Pat Ryan, became involved in a

**Below:** The renaissance-inspired artwork of Alex Raymond made *Flash Gordon* the best drawn comic strip of all time. This episode, from 1936, is one of the best.

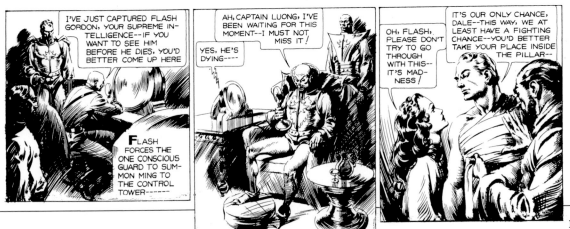

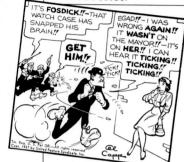

**Above:** No American institution was safe from the savage pen of Al Capp. His famous character *Li'l Abner* brought his "downhome" plain talking to bear with devastating effect. Here, Abner's "ideel" *Fearless Fosdick,* points to the absurdities in the later adventures of *Dick Tracy.*

nightmarish world of intrigue and drug-smuggling. Head of the drug-pushers was an exotic Eurasian woman called The Dragon Lady. Caniff's drawing style was deceptively simple, but produced a sophisticated result. The material holds up well today.

That year also marked the introduction of satire to the comics. Al Capp's *Li'l Abner* strip worked by using its simple-minded hillbilly hero as a yardstick against which to compare the foibles of society. Relentlessly pursued by the marriage-mad Daisy Mae, Abner resisted for nearly 20 years until his favorite comic hero, "Fearless Fosdick," a wicked parody of Dick Tracy, became the husband of *his* long-time fiancée.

### Comic books get creative

During the mad scramble to sign up the reprint rights of newspaper strips for the new comic books, one of the losers was an independent publisher called Major Malcolm Wheeler-Nicholson. In 1935, he assembled a comic book filled with a mixture of historical adventure and humor and titled it *New Fun Comics*. The publication was a modest success, so Wheeler-Nicholson added a companion title, *New Comics.* Within months *New Comics* changed its name to *Adventure Comics*, while *New Fun* became *More Fun.* These titles were printed by a pulp-magazine publisher, Harry Donenfeld, who eventually took over the comics from Wheeler-Nicholson, turning only a modest profit in the process. Donenfeld's fortunes changed when he added a new comic whose initials were to give his whole company its name, *Detective Comics* (1937). In essence, *Detective* simply transferred the themes of the "Black" detective pulp magazines – which featured the work of such writers as Dashiel Hammett and Raymond Chandler – to the comic-book page. This formula was a huge success. But it was to become even bigger with the addition of a new character, The Batman. However, before that could happen, Donenfeld would have to unleash on the US public the adventures of Earth's first alien visitor.

In a companion magazine to *Detective Comics*, Donenfeld published a new strip, *Superman*, by a couple of newcomers, Jerry Siegel and Joe Shuster. The new book was called *Action Comics* (1938) and featured Superman on the cover. By the fourth issue, *Action* was selling out at the newsstands, and nobody could figure out why. A little detective work revealed the cause. The new character, Superman, in his red-and-blue leotard-type costume, was what had grabbed the public attention. Donenfeld ordered the character to be featured on the front cover of every issue of *Action.* From there, Superman's success was irresistible. The "superhero" had arrived.

### Pioneering spirit

Meanwhile, back in the newspapers, Will Eisner's *The Spirit* (1941) made his first appearance. *The Spirit* was the star of a 16-page comic book given away with the Sunday editions of many US newspapers. Although these early efforts were competent enough to keep the feature going, it was not until after his return from war service that Eisner really began to set the comic medium on its end. From 1946 onward, *The Spirit* became a showcase of just what could be done with comics as an artform. And, happily, Eisner is still alive and working today, still pushing the boundaries of comics to their very limits. (Recommended reading for anyone interested in *good* comics are *The Spirit* reprints from Kitchen Sink Press, available at any specialist comics shop, along with Eisner's "graphic narratives," *A Contract with God* and *The Big City.*)

Alex Raymond, the creator of *Flash Gordon*, began a new strip in 1946, *Rip Kirby.* A detective in the gentlemanly tradition of Sherlock Holmes, Rip was a bespectacled, pipe-smoking intellectual. The strip never had the sparkle of *Flash.* In 1947, Milton Caniff followed up the success of *Terry and the Pirates* with *Steve*

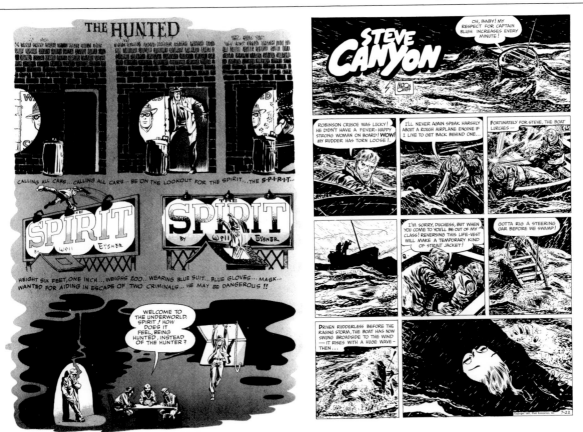

Canyon, about an ex-pilot who undertakes all manner of daredevil missions in an effort to raise sufficient funds to keep his ailing airline aloft. The new strip was every bit as good as *Terry* ever was. Notable additions to the newspaper strip during the early 1950s included *Peanuts* (1950), *Beetle Bailey* (1950) and *Dennis the Menace* (1951).

## "Gasp! Choke! It's E.C."

In the comic-book field, as the 1940s drew to a close, and the costumed heroes fell prey to drooping sales figures, the industry cast around for "the next big thing." Crime comics were doing good business in those post-war years. Their violence and graphic depiction of criminals' methods made them the top-selling books of the time. Romance comics, too, got their first toehold around this time. But the really big sales grabber of the late 1940s and early 1950s was the horror comic. And the leader of the pack in the horror stakes was the line produced by Bill Gaines, head of EC Comics.

Bill was the son of Max, the founding father of the comic-book business. When Max had died in 1948, Bill had inherited the modest comics company his father had been reduced to, Educational Comics. For the first couple of years, Gaines experimented by changing the titles his father had left him. *Picture Stories from the Bible*, *Animal Fables* and *Tiny Tot Comics* were not what the younger Gaines thought made commercial comics. So, instead, he concentrated on the already established lines of crime, romance and western comics, including *War Against Crime*, *Modern Love* and *Saddle Justice*. While reasonably success-ful, these comics were not topping the lists. Then, pushing his experiment further, Gaines included a horror yarn, introduced by a macabre comedian called

**Above left:** Will Eisner's *The Spirit* was a pioneer of comic strip story-telling which used flashy narrative tricks. **Above:** Milton Caniff's *Steve Canyon,* on the other hand, used a no-nonsense – but no less inspired – approach to graphic narrative.

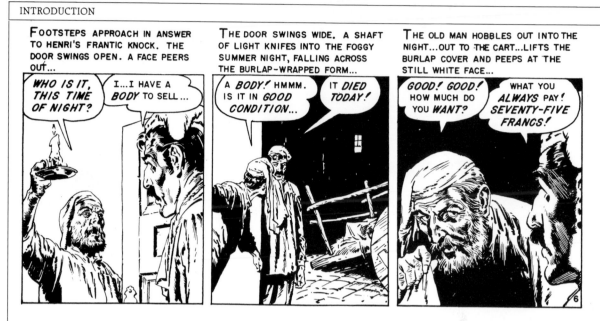

FOOTSTEPS APPROACH IN ANSWER TO HENRI'S FRANTIC KNOCK. THE DOOR SWINGS OPEN. A FACE PEERS OUT...

WHO IS IT, THIS TIME OF NIGHT?

I...I HAVE A BODY TO SELL...

THE DOOR SWINGS WIDE. A SHAFT OF LIGHT KNIFES INTO THE FOGGY SUMMER NIGHT, FALLING ACROSS THE BURLAP-WRAPPED FORM...

A BODY! HMMM. IS IT IN GOOD CONDITION...

IT DIED TODAY!

THE OLD MAN HOBBLES OUT INTO THE NIGHT...OUT TO THE CART...LIFTS THE BURLAP COVER AND PEEPS AT THE STILL WHITE FACE...

GOOD! GOOD! HOW MUCH DO YOU WANT?

WHAT YOU ALWAYS PAY! SEVENTY-FIVE FRANCS!

**Above:** An example of comic-book horror in the *E.C.* style by one of the company's finest draftsmen, Reed Crandall. **Opposite:** Although *E.C.* comics were put out of business in 1954 by the introduction of the *Comics Code,* they continued to publish *MAD* magazine. This page is, in its own way, no less horrific than those early *E.C.* stomach-churners.

The Vault Keeper, in *War Against Crime.* In fact, he had so much fun slipping horror and science-fiction tales into his regular titles that, without waiting for reader response, he went straight ahead and switched all his publications to horror and science fiction. Within months his crime and romance titles had vanished to be replaced with *Vault of Horror, Crypt of Terror, Haunt of Fear, Weird Science* and *Weird Fantasy.* These books were far more sophisticated than any of their rivals, and consequently sold only moderately well. Yet, within a couple of years, the shoddier imitations of Gaines' books put out by other publishers had become so outrageous in their gore and violence that something had to be done. Gaines was called upon to testify at a Senate hearing on juvenile delinquency and, while no link could be found between the horror comics and rising child crime, the connection made between the two in the public's mind caused enough furore for legislation to be introduced to kill off the horror comics – good and bad – forever.

Saddled with an industry-imposed standard to adhere to – the Comics Code, inaugurated in 1954 – the comic books stayed harmless for years. Of Gaines' popular line of comics, the only survivor was *Mad* – and, to avoid the Code, this was changed from a four-color book to the magazine format it enjoys today.

The late 1950s was a directionless time for comics, both in the newspapers and in the comic books. Until, that is, the revival of the superhero.

### A comics Marvel
In 1961, an outfit called Marvel Comics, which had enjoyed a big success during the 1940s with the adventures of such characters as The Human Torch, The Sub-Mariner and Captain America, decided to re-enter the costumed-hero field. During the early 1950s, the company had scratched an existence by putting out crude imitations of the EC horror comics. When the Code came along in 1954 and made graphic horror a no-no, Marvel switched to publishing laughable monster tales about creatures from other dimensions with names like "Tim-Boo-Bah" and "Fin-Fang-Foom." Then, seeing their wartime rivals, DC Comics, scoring a moderate success with revivals of their 1940s superhero characters, Flash and Green Lantern (Superman and Batman had somehow weathered the lean years intact), Marvel decided to take a whack at costumed characters. But Marvel editor Stan Lee did not want just to copy the DC style of character. His idea was to create a more realistic type of superhero, someone with whom the kids could

identify, a character who might react as you or I would if we were suddenly endowed with abilities beyond those of normal folk.

To this end, Marvel published the first issue of *The Fantastic Four* in 1961. The stars were a group who undertook a privately financed space mission which went awry and left each of the four with unearthly powers. The leader, Reed Richards, gained the ability to stretch his body, his fiancée Sue became invisible, her brother Johnny was able to burst into flames (becoming The Human Torch), and their pilot Ben became a lumpy orange monster with fantastic strength, The Thing. At first, the group didn't even have costumes, preferring to operate in street clothes. But corporate pressure became too much, and soon they all sported skintight blue pajama suits. Yet, unlike all their predecessors, The Fantastic Four spent much of their time bickering among themselves, arguing over who would be leader, deserting each other in moments of crisis, and

displaying other typically human traits. The series was a huge hit and soon Lee had added other misfit heroes to his lineup of comics: Spider-Man, a teenage nerd who was the butt of college jokes in his civilian identity of Peter Parker; The Hulk, a tormented green monster, a kind of cross between Frankenstein's monster and Jekyll and Hyde; and Thor, the Norse God of Thunder, who changed into crippled Dr. Don Blake if he put his hammer down for more than 60 seconds. A more neurotic bunch has never stalked a four-color page.

The hippy era and drug culture of the late 1960s gave birth to the "underground" comic books. These weren't *really* underground comics. They were given the name because they were distributed through the "head" shops and record stores rather than via the news-distribution system. One of the first of these was Robert Crumb's *Zap Comix*. Crumb went on to create *Fritz the Cat* and *Mr. Natural*. In his footsteps came Gilbert Shelton's *Wonder Warthog* and *The Fabulous Furry Freak Brothers*, and such cartoonists as Skip Williamson, Jay Lynch and Denis Kitchen.

### The fandom revolution

Comics continued pretty much the same, give or take the odd title, for the next 10 years, with steadily declining sales. Critics and fans alike were predicting the demise of "the US comic book as we know it" inside five years...until something happened that nobody had foreseen. The specialist comics shops had been springing up around the United States and Europe since the mid-1970s. These were bookshops which specialized in comics of all types. Some diversified into distribution, albeit on a small scale, and began to supply retail outlets in other countries. By the end of the 1970s, every major city in the United States, Canada and Europe had at least one "comics shop." A huge percentage of all comics being sold were going to older readers, particularly those who had grown up with Stan Lee's Marvel Comics during the 1960s and were reluctant to let their hobby go. Comics "fandom" was a growing force. Comic conventions, in existence since the mid-1960s, became huge affairs, with whole hotels being taken over for entire weeks and literally thousands of comics fans and professionals in attendance. To be a successful comics creator was also to be a superstar a couple of weekends a year. So it was only natural that, in 1981, certain specialist distributors contracted comics professionals to produce the sort of comics that the fans wanted to buy, rather than comics that the conglomerates wanted to produce. Eclipse Comics, a company which had produced a couple of "graphic novels" (that is, comics published as oversized paperback books in low print-runs), put out the first issue of *Eclipse Monthly*, an anthology title which included many top comics creators among its list of contributors. Other small publishers entered the field: First Comics, Pacific Comics and Fantaco were among the earliest of these.

**Below:** The eccentric drawing style of Robert Crumb, probably the most famous comic strip creator to emerge from the "Underground" comics of the late Sixties.

**Left:** A page from Howard Chaykin's excellent, if violent, *American Flagg!* published by *First Comics*. Note how Chaykin integrates the sound effects lettering into the artwork, making it an integral part of the story-telling process.

To further entice the big-name creators away from the big-name publishers, these specialist comic-book publishers began to offer royalty deals and ownership of copyright to the creators. The conglomerates, faced with the prospect of losing their top talents, were forced to match or better the deals being offered by the small-time outfits.

By the end of 1986, some of the best comics on the market were being published by these small companies. While a full listing is impossible here, mention should be made of *Cerebus the Aardvark* (Aardvark-Vanaheim), *Miracleman* (Eclipse), *Love and Rockets* (Fantagraphics), *Jon Sable* (First) and *American Flagg!* (First).

Never has the comic-book business been in better shape. Although more comics were sold during the war years, the creators were virtual slaves of the publishers. Nowadays, although the newspaper-strip side of the business has worn away to a shadow of its former self, with only a lucky few able to make the big bucks, the comic-book business has changed drastically, allowing a reasonably competent creator a good living if he is a diligent worker. And rather than shrinking, as it was during the 1970s, these days the comic-book business is actually a growth industry, hungry for new talent and new ideas. In fact, with royalties being paid to a large proportion of creators by the comics companies, comic books can be financially more rewarding than the newspaper strips.

A final note: at the time of writing, the best-selling comic book in the United States is Marvel's *The X-Men* – as it has been for the last 10 years or so.

# Comics Around the World

Comic strips have developed differently in different countries: the wider the cultural gap between countries, the more pronounced the differences in their comics. In this chapter, we shall consider examples from the United States, the United Kingdom, Europe and the Far East, and look at the different approaches used by each.

### The United States

US newspaper comic strips are now, sadly, in a decline. The days when a nation held its breath to see whether Dick Tracy would escape the latest trap or whether Flash Gordon would defeat the evil Ming yet again are long gone. The much-loved adventure strips of years gone by seem to have almost disappeared. The few remaining dramatic comic strips are either rugged survivors from the Golden Years of the 1930s and 1940s, like *Steve Canyon*, or licensed properties based on the movie successes of recent years, like *Star Wars*. The only newspaper strips in the United States to survive on their own terms seem to be the humorous ones, like *Garfield* and *Hagar the Horrible*.

US comic books – published as 32 pages printed in mechanically separated color on newsprint with glossy color covers – are another matter. After the sales slump of the 1970s, the US comic book is climbing back toward large profits thanks to the advent of the specialist comics shop. Before comic shops, comic books were sold at newsstands on a "sale-or-return" basis. This meant that comics companies had to print far more copies than they were likely to sell – if a comic sold 50 percent of its print run, the publisher was doing well. Needless to say, this was a very wasteful way to go about selling magazines. By selling to specialist outlets like comic shops on a firm basis, with unsold copies being unreturnable, publishers could decrease wastage and increase profits. This arrangement presents no problems to comic shops, because they can sell residual copies as "back issues" the following month for even more than the cover price. Approximately half the comics sold in the United States are sold through these specialist outlets.

**Below:** The highly individual and charming work of Howard Cruse. This strip, *Wendel,* takes an affectionate look at the lifestyle of a gay family, comprising son, father and father's lover.

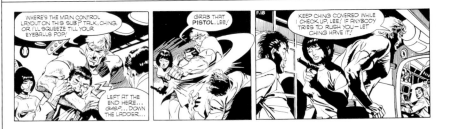

**Left:** The superb rendering of Frank Bellamy on the *Daily Mirror* newspaper strip, *Garth*.

Another factor which has changed the publishing habits of the US comic-book companies is that audiences are now, on average, older, and themes treated in comic books are consequently becoming more adult, without straying into the drug- and sex-oriented country of the Underground Comics left over from the 1960s. This seems to be because the huge audiences brought into the comic-buying arena by Stan Lee's revolutionary Marvel Comics of the mid-1960s have apparently stuck with comics; i.e., the comics being produced seem to have grown up with their audiences. So, while there is still a market for the juvenile-oriented superhero comic books, more adult magazines, like DC's *Swamp Thing* and Marvel's *Conan the Barbarian*, have survived happily alongside.

Added to these are the comics put out by the new independent publishers, companies that produce comics aimed at the fans and sold exclusively through the specialist comic shops. Titles which seem to be doing well in this area are First's *John Sable, Freelance*, Comico's *The Elementals* and Renegade's *Ms Tree*.

All of this adds up to a growth industry hungry for new talent.

## The United Kingdom

Opportunities for UK-originated newspaper comic strips are limited these days,

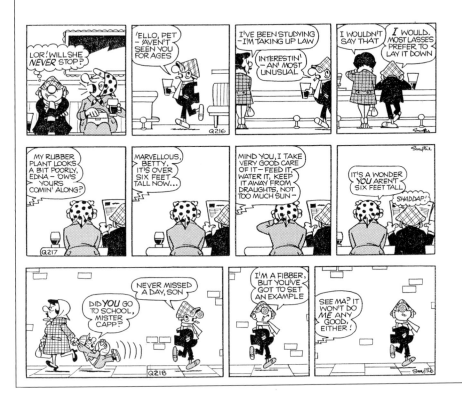

**Left:** Another *Daily Mirror* strip, *Andy Capp*, telling of the misadventures of an unpleasant layabout.

as so many strips are now picked up from US syndication agencies. However, there are a few notable home-grown newspaper strips. *Modesty Blaise* is still going strong, as is *Garth*, which has appeared in the *Daily Mirror* for more than 30 years. There is even a newspaper strip of *Judge Dredd*, the character made famous by IPC's *2000 AD* comic. On the funny side, Frank Dickens' *Bristow*, a strip about a mousy office worker, continues to entertain readers of the London *Standard*, and Andy Capp, the loutish unemployed wastrel, is still one of the UK's best loved comic characters.

The comic-book business in the United Kingdom has always been geared especially toward the youth market, primarily in the 8–12 range. There are three main companies operating in the United Kingdom – one of which is simply the UK end of Marvel Comics. The magazine giant IPC makes most of its money from periodicals like *Woman's Own*, which sells over a million copies per week, but continues to operate its "Youth Group" with *2000 AD*, the anarchic science-fiction comic, as its bestseller. Within the pages of *Battle*, stoic British soldiers are still fighting World War II against awful Nazis who utter dialogue like "Gott im Himmel" and "Britisher Schweinhundt." These books feature episodic stories of five or six pages per week. Aimed at a slightly younger audience, funny comics like *Buster*, starring Andy Capp's son, and *Whizzer and Chips* generally contain single-page stories in which the heroes are usually rewarded for some good deed with a slap-up meal of bangers and mash.

The Scottish company D.C. Thomson produces four main titles: *Dandy*, *Beano*, *Topper* and *Beezer*, all of which have been running since the 1930s. Their format is similar to the funny comics published by IPC: 20 pages of single-page strips on newsprint paper of shocking quality. However, somebody must be buying this stuff since the *Beano*, in particular, is phenomenally popular.

### France and Belgium

In Europe, both youth- and adult-oriented comics seem to coexist peacefully. France, in particular, enjoys a healthy market for adult comics which are not seen as Undergrounds. This adult market is dominated by *Metal Hurlant*, an

**Below:** The legendary *Asterix the Gaul* by Goscinny and Uderzo.

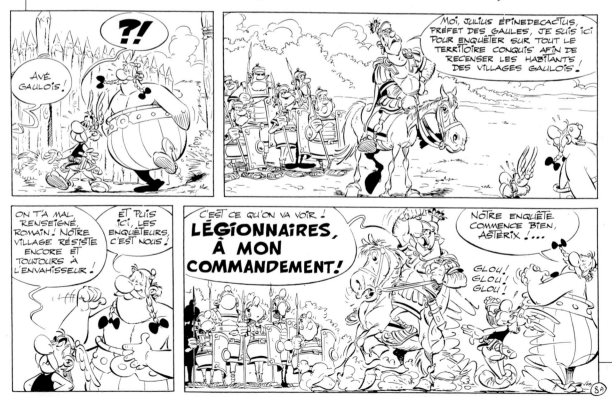

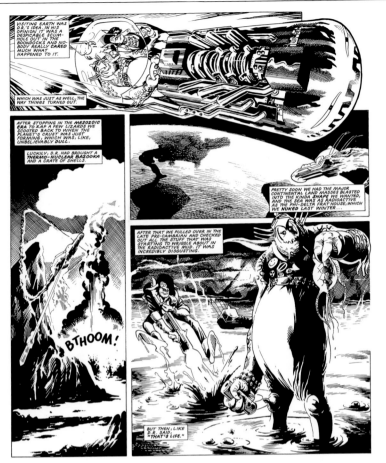

expensive, glossy comic magazine published also in a US edition called *Heavy Metal*. There are some quite successful imitations of *Metal Hurlant*: *L'Echo Des Savanes*, a comic magazine founded by now-famous cartoonist Claire Bretecher and her partner Marcel Gotlib, and *Pilote* are among the foremost. Strangely, the concept of adults reading comics does not seem to draw the scorn in France that it does in the United States and the United Kingdom.

At the younger end of the French-language scale are phenomenally popular properties like *Tintin*, created by the Belgian Hergé, *Asterix*, created by Frenchmen Goscinny and Uderzo, and *The Smurfs* (or *Schtroumpfs*, as they are called in their native country) by the Belgian Spirou. All have been translated into English and are available in the United Kingdom and the United States, as well as being exported to just about every country in Europe.

Other popular French-language comic characters include the laconic cowboy Lucky Luke, Jean Giraud's excellent Lt. Blueberry (Giraud is the real name of the bizarre cartoonist "Moebius," whose work has appeared extensively in the US *Heavy Metal* magazine) and Jean-Claude Forest's science-fiction heroine Barbarella, whose adventures were filmed by Roger Vadim in 1966.

## Italy

Comic books in Italy are generally published in a sort of digest format, measuring approximately 6in × 4in, and printed in black-and-white on rough newsprint inside gaudily colored covers. As with the French, the Italians produce comics designed for readers of all ages.

One of the most famous Italian comics characters is Diabolik, a sort of

**Above:** In France, not all comics are for children: an example of mature cartooning from Jean Giraud (Moebius).

**Above:** A page from Italy's most successful comic, *Diabolik,* a series about a righteous supercrook and his girlfriend Eva.

**Right:** Unlike other countries, Italy continues to love tales of the American Wild West. *Tex* is one of the better examples of Italian Western strips.

costumed supercrook who spends all of his adventures committing crimes designed to make his adversary, a bumbling Italian police inspector, look bad. This character made it into the movies in 1967, courtesy of Dino de Laurentiis. There is a comic devoted to a cowboy called Tex, while the costumed adventurer Mister No also has his own book. Il Comandante Mark is a sort of period adventurer who rights wrongs in 18th-century America. *Martin Mystère* is a "*detective dell'impossibile*" who seems to spend his time solving supernatural cases.

These comics seem to be aimed at a general audience, but some Italian comics are designed exclusively for adult consumption. *Terror* is an anthology title which depicts horror of the most graphic kind: graphic sex scenes, both heterosexual and homosexual, several scenes of sexual mutilation, and some of the most graphically sadistic torture I have ever seen anywhere. The copy I have has a truly bizarre sequence in which a young girl is forced to have sex with assorted vegetables. In the same vein, the magazine *Zora* stars an extremely well developed vampiress (the Zora of the title) who, for example, in one story is forced to drink a youth serum which turns her into a 13-year-old nymphet. The resulting sex scenes would have a UK or US publisher run out of town.

### Germany
Germany has no real indigenous comic industry. The best selling comics in the Federal Republic are the Walt Disney comic strips featuring Mickey Mouse and Donald Duck, published in a weekly comic called *Mickey Maus.* German-language reprints of Marvel Comics' best known characters are well represented, with such characters as "Der Silber Sturmer" and "Prinz Namor" among the most prominent.

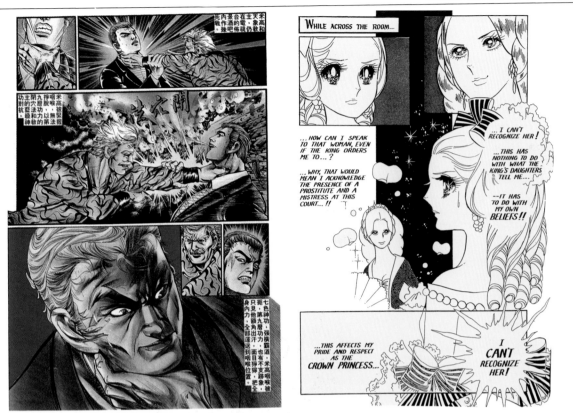

## The Far East

Oriental comics are a revelation to our eyes, not least because they are read *backward*; that is, a reader begins at what we would call the rear of the book and reads toward the front. Each page is read from right to left down the page – the right-hand page first, then the left-hand one. It is very difficult to get used to after a lifetime of reading comics in the opposite direction!

In Hong Kong, there is a thriving comics industry. There are many martial-arts comics featuring boxers, swordsmen and other assorted wielders of exotic weapons who enjoy adventures set in all kinds of time-periods. Then there are romance comics: the kind of love affair depicted indicates that the product is aimed at the 13-year-old girl reader. There are horror comics available, too. The format of most of these publications resembles that used for most US comics: four-color on newsprint, with glossy color covers.

In Japan, the comics are rather like the Italian digest-sized comics but are printed in superior color. A single comic can have as many as 300 pages, and each issue usually contains only one episode of an interminably long story, running to thousands of pages. The subject matter would boggle the imagination of the average Western comics creator. Sports stories are very popular. Edging toward the ridiculous, there are also Mah Jong comics! The romance comics are a little stranger than those found elsewhere. The story from which we have reprinted an example, *The Rose of Versailles*, involves the tale of a girl who disguises herself as a man, becomes an officer in a palace guard in Royal France, and then has to cope with the fact that a beautiful princess is in love with him…or, um, her. Science-fiction comics involving giant robots are very popular, too, but surely the strangest of the lot must be *Barefoot Gen of Hiroshima*, a grueling account of a youngster who survives the bombing of Hiroshima.

**Above left:** A page of Kung Fu comics from Hong Kong. **Above:** An example of a Japanese romance comic, *The Rose of Versailles*. **Below:** The Japanese seem fascinated by the horror of Hiroshima. This example is from *Gen of Hiroshima*.

# PART 2
## MASTERING THE COMIC STRIP

# The Equipment

As in any branch of creative art, the choice of equipment is an intensely personal one. However, because of the peculiar requirements of comic-strip art and the limitations within which the artist must work, only certain drawing materials will be of any use.

The first task of *any* artist is to establish a space to work. Some people may be able to produce wonderful artwork lying on the living-room floor with family and assorted pets crawling all over them – but I doubt it. The ideal situation is to have a separate room set aside where you can spread yourself out and fit a desk, bookshelves for reference materials, filing cabinets for your picture files, and storage space for your art supplies. Of course, if you have limited space this is not possible. In this case, a corner of the room which can be left undisturbed when the inspiration temporarily runs out will have to do.

### The desk and chair
It sounds obvious, but you really must have a desk (or table) to work at as well as a comfortable chair to sit on. Remember, you are going to be over your artwork for hours at a stretch – if you are serious about it – and the first consideration is your physical comfort and health. Back trouble is the single biggest cause of man-hours lost through sickness in the western world, so your desk set-up should be arranged to minimize backstrain.

The way to do this is to ensure that the artwork you will be working on is high enough so that you do not have to lean over it; your back should be as straight as possible. This means you need some kind of sloping drawing board. Freestanding drawing boards designed especially for artists, complete with parallel-rule attachments, are available, but they represent an expensive investment for the beginner. Alternatively, and more cheaply, there are similar drawing boards which rest on top of a desk or table. Most big cities have stores which deal in used office furniture, and you should have little difficulty in obtaining such equipment in one of them. However, if you are of limited means – and who isn't these days? – a simple table with a home-made drawing board will do the job just as well.

As for something to sit on, a typists' swivel chair with a facility for adjusting the height is a good starting point. Again, these can be obtained second-hand quite easily. If you have a little more money to spend, there are "chairs" available on which you sort of half-kneel and half-sit. These are designed to keep your back as straight as possible while you work, and are made under many brand names.

A useful additional piece of equipment is a light to work by. The standard adjustable desk lamp is cheap, readily available, and ideally suited to the purposes of most artists. However, there are more sophisticated models on the market, some of which attach directly to the drawing board and some of which carry a small striplight rather than a standard lightbulb.

Once you have all the heavy equipment sorted out, you will need something to draw with and something to draw on...

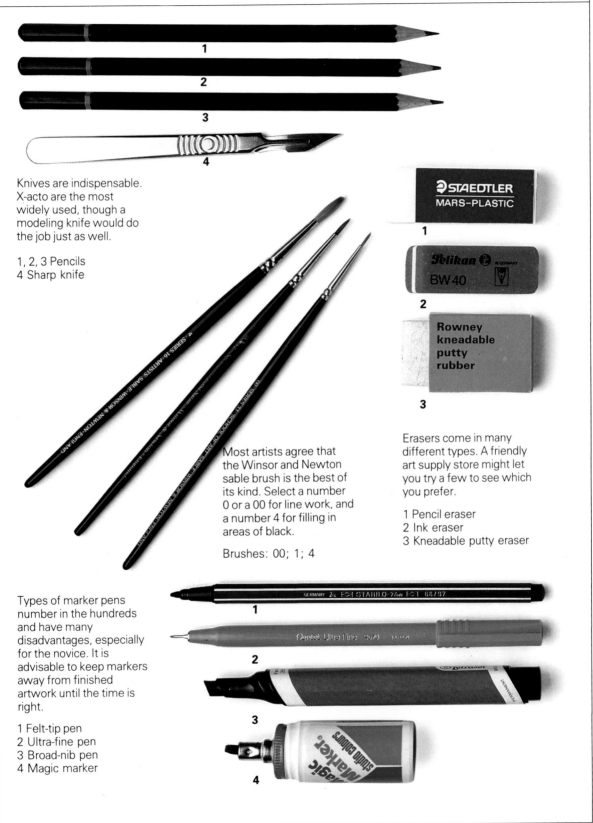

Knives are indispensable. X-acto are the most widely used, though a modeling knife would do the job just as well.

1, 2, 3 Pencils
4 Sharp knife

Most artists agree that the Winsor and Newton sable brush is the best of its kind. Select a number 0 or a 00 for line work, and a number 4 for filling in areas of black.

Brushes: 00; 1; 4

Erasers come in many different types. A friendly art supply store might let you try a few to see which you prefer.

1 Pencil eraser
2 Ink eraser
3 Kneadable putty eraser

Types of marker pens number in the hundreds and have many disadvantages, especially for the novice. It is advisable to keep markers away from finished artwork until the time is right.

1 Felt-tip pen
2 Ultra-fine pen
3 Broad-nib pen
4 Magic marker

Always ensure that you have sufficient light to work by. Eyes can become tired very quickly working under poor lighting conditions.

## Pencils

Pencils are absolutely essential. Nobody, but nobody, draws directly onto their paper or board with ink. The finished art is always roughed out in pencil first. And, when it comes to pencils, there are several different types an artist can choose. The most common is the standard wooden lead pencil, which comes in a variety of grades – 8B, the softest and blackest, through to 8H, the hardest and lightest, with HB marking the midway point. The grade of pencil you use is entirely up to you. However, it should be pointed out that the very softest pencils have a tendency to make lines which smear easily and the very hardest make lines you can hardly see, unless you press extremely hard. The best thing to do is to buy a selection and try them yourself, although the most common pencils for comic-strip work are HB and B.

If you are going to use wooden pencils, you will need something to sharpen them with. The standard type of pencil sharpener you had during your schooldays will do the job, as will the luxurious electric pencil sharpener. The advantage of these sharpeners is that they tend to produce a regular shaped lead. But the X-acto knife with replaceable blades, puts the best point on any pencil. Most art-supply stores carry X-acto knives and blades. A word of caution, though. Always treat these knives with a good deal of respect. They are very sharp and you won't realize you have cut yourself until it is too late. I cut off the top of my finger with one the first week I worked in the art department of a London comic-publishing house. It didn't really hurt at the time, but I suffered from shock and very nearly passed out. And, of course, I could not handle artwork properly for about a week. I had a great deal of respect for knives after that, and have not made the same mistake in the 12 years since!

The other type of pencil much favored by comic-strip artists is the mechanical or "clutch" pencil. There are many brands on the market. Rexel and Staedtler are two of the better known. These pencils can be loaded with leads of any grade and generally have special built-in sharpeners with which to touch up the point – although again I recommend you to use your X-acto knife to keep your lead sharp.

A second type of mechanical pencil uses a much thinner lead than the standard clutch pencil. The advantage of these pencils is that they do not need sharpening. The one I use is made by Mitsubishi.

You will also, of course, need a pencil eraser. For me there is one only choice: the Rotring pencil eraser. However, some artists swear by the kneaded eraser, which can be kneaded into various shapes.

## Pens

The subject of pens is vast. Luckily, there are only a few types that are really suitable for the comic-strip artist.

Because the comic-strip artist is pretty much obliged to use India ink, the ordinary fountain pen is ruled out. India ink dries and clogs a regular fountain pen before very much can be accomplished. A simple dip pen is the only viable alternative. These come in a variety of shapes and sizes. Which you choose is very much up to you. Make sure you find a handle which is comfortable to hold. Too thin a handle and you will have cramp in the hand inside an hour. A pen handle can be thickened by winding it with masking tape.

The Rolls-Royce of pen nibs is the Gillot steel nib. With this nib an artist can vary the thickness of the line he or she is putting down by varying the pressure. Most art-supply stores carry Gillot nibs. The "crowquill" or mapping nib is also widely used among comic-strip artists.

Dip pens are of course time-consuming, and the Rotring stylo-type pens, with their tubular nibs and India-ink cartridges, can be very useful. Although the line produced by such pens is constant and therefore a little too boring for actual artwork, stylo pens can be useful for ruling straight lines, especially panel

borders, and can also be used for lettering speech balloons. However, a pen called the Speedball, which has a small reservoir attached to hold more ink, is the favored pen for lettering. It is easily available in the United States, although a little more difficult to find in Britain.

In the last few years, pen technology has made some considerable advances. Many comic-strip artists are experimenting with fiber pens, plastic-tipped pens and felt markers. Neal Adams, best known for his extraordinary work on *Batman*, *Green Lantern/Green Arrow* and *Deadman* during the 1970s, uses a Pentel marker for inking his work. Alex Toth, veteran comic-strip artist, uses felt markers to achieve his bold, thick-lined inking style.

But for novices it is probably best to master the basic dip pen before experimenting with new technology.

### Brushes

When it comes to linework for comic-strip art, there really is no better brush than the Winsor & Newton sable, size 2 or 3. Just about every professional in the field picks one of these two brushes as his or her favorite, although larger brushes can be used for filling in areas of black. Will Eisner, veteran of *The Spirit*, has Winsor & Newton brushes he has owned for 20 years.

To keep a brush operational for that amount of time requires special care to be taken. Most professionals agree that a Winsor & Newton will last forever if it is looked after properly. Try to get into the habit of washing out your brush with water as often as possible. This will stop the ferrule becoming clogged with ink: if the ferrule clogs, the hairs of the brush splay outward, effectively destroying the point.

Bear in mind the old saying: "You get what you pay for." Cheap brushes do not have the resilience of the sable type and wear out more quickly. They therefore represent a false economy.

### Inks

India ink is used because of the dense black lines it produces. Black ink designed for fountain pens tends to be a little thin and therefore too gray for comic-strip work. Remember that you will be drawing for reproduction by some kind of photographic printing process, so it is less important that your artwork looks good to the naked eye than that the black lines you make look black to the printer's camera.

Some India inks, especially the cheaper kinds, can be a little thick. This is not a problem when it comes to photographic reproduction, but it will cause headaches when the ink starts to clog your pens and brushes. The India ink designed for use with the stylo-type pens – Rotring is a well known brand – is slightly thinner, but quite dark enough for comic-strip purposes.

As India ink gets older, it tends to thicken up because of evaporation. A drop of water fixes this. A word of warning, though: it is best to use distilled water for thinning old ink. Tap water, especially in hard-water areas, tends to contain impurities which can cause the particles suspended in India ink to clump together. Although not visible in regular use, these clumps become obvious when you thin the India ink down to use in wash work, when you need areas of gray.

A simple test for quality when buying ink is to draw a line with a brush or pen and wait until the ink dries, then hold the paper up to the light. If the dried ink line shows up as being slightly raised from the paper, the ink contains plenty of shellac (an important ingredient in India ink). If the ink has soaked into the paper, it contains too little shellac and therefore is of inferior quality.

Erasing areas of dried ink can be difficult. Depending on the surface of the board or paper you are using, it may be possible to scratch out errors with the point of your X-acto knife. Alternatively, you could try sticking a piece of patch paper over

A radio is a useful source of inspiration for artists but it can be distracting for writers.

the error and redrawing the area. Suitable self-adhesive patch paper – one brand is Tik-Tak – can be bought from most art-supply stores. The other method of correcting inking errors is to use either spirit-based typewriter-correction fluid – brands such as Liquid Paper are readily available – or water-based process white.

## Paper

As with every other type of supply, an artist's paper is very much a case of personal choice. However, as a general principle, a layout pad will be useful for thumbnail sketches and character studies, and a box of regular typing paper is handy for working up your initial breakdowns of comic pages.

The usual size of comic-strip artwork is one and a half times its printed size. Thus the art on a standard comic-book page for a US comic is printed 6in × 9½in from artwork 9in × 14¼in. The size of art for British comic papers tends to be proportionately wider, printing at 8¼in × 9½in from artwork drawn to 12⅜in × 14¼in. It is advisable to ask the editor for the correct dimensions.

Sizes for newspaper comic strips and European comics vary a little more, so it is best to check for yourself. However, a good average for drawing a newspaper strip is 13in × 3¾in.

These days the larger comics companies supply their own preprinted board to artists for finished artwork. This has a grid to the appropriate dimensions printed on each sheet in pale blue ink (which will not reproduce under the printer's camera). In this way, the companies can be sure that the artwork produced is drawn to the correct proportions. The actual board supplied is invariably some kind of two-ply Bristol board measuring about 10in × 15in, allowing for borders, often with a slightly rougher than usual surface which is geared more toward penwork than brushwork.

"Hot-pressed" board has a slightly glossy surface achieved during manufacture when the board is pressed between two hot rollers to dry it. This surface is fine for comic-strip work, although it will repel India ink where it has picked up oil from the artist's fingers. The shinier the board, the more of a problem this can become. "Not" board has a slightly rougher surface. It is *not* hot-pressed during manufacture, which accounts for its less smooth finish, or "tooth." Ideally the comic-strip artist needs something between the two types: not too shiny, not too rough.

There is a type of illustration board called CS10 which is very popular among some illustrators. This is a thick board – about ⅛in thick – which can take pen-and-ink and colored inks quite well. The big problems with it are that it picks up fingerprints easily, leading to repulsion of inks, and that it is heavy. Its weight is no problem when the board is used for newspaper-type comic strips, but if you were to try to send a 20-page comic-book story drawn on CS10 through the mail, especially by air mail, your postage could well come to more than the check you receive from the publisher.

## Writing materials

If you are interested in writing comic strips to be drawn by an artist other than yourself, you have to bear in mind that these *have* to be typed. No comics editor in the business will put a handwritten manuscript at the top of his "must read" pile. This means you must invest in a typewriter.

If you are not planning on doing much writing, a portable typewriter will do the job just fine. If you are determined to make a career out of writing, though, an electric or electronic typewriter is pretty much essential. The Canon Typestar 7 is a reliable, quiet electronic typewriter with a small memory capacity, and is well suited to the job of typing up short scripts. However, if scripting is going to be a major part of your work, a small word processor makes life a good deal easier. This book was written on an Amstrad PCW 8256, a machine which,

**Below:** It pays to keep your brushes, pens and pencils together in some kind of a container to keep your desk tidy. *Never* store brushes or pens point-down in such a container.

although a little slow in operation, is a perfect word processor for any kind of writer. The big advantage of a word processor is that it eliminates the need to make carbon copies of your scripts and also allows you to have ready access to further copies of your manuscript.

## Other equipment
Other pieces of equipment are best acquired as you find a need for them, but recommended items for your starting kit are: a pot of water for cleaning your brushes; a steel rule, for cutting up board with your X-acto knife; a triangle; ink and pencil compasses; push-pins, to tack drawing paper to your board; and a roll of paper towels, for wiping brushes, pens, ink spills and water splashes.

A final tip... if you find a type of paper, pen-nib or whatever that suits you perfectly, it is best to buy a good supply while you have the chance. Many art-supply manufacturers will discontinue without warning lines which do not show enough profit. So you can go back to your local supplier three months after finding the best type of Bristol board ever made only to find it ain't made any more!

Now that you have your equipment sorted out, let's think about the task of drawing...

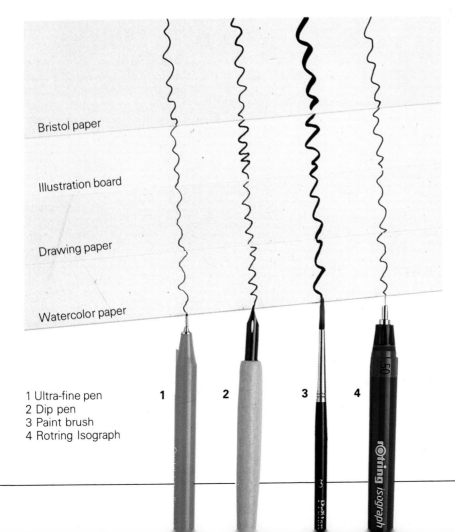

Bristol paper

Illustration board

Drawing paper

Watercolor paper

1 Ultra-fine pen
2 Dip pen
3 Paint brush
4 Rotring Isograph

The choice of board surface will depend on what kind of job you are doing. As can be seen from these examples, each surface responds differently to various drawing tools.

Each of these drawing tools will produce a different quality of line and can be mixed within the same drawing to achieve assorted textures and effects.

# Basic Elements

The art style used for comic strips is different from that used by any other form of artwork other than storyboards for movies and commercials (to which the strips are closely related). For comic strips have an additional element: they have to tell a story and thus they have to depict the passage of *time*. Each frame in a comic strip is a frozen instant. Between frames, the creators and the readers "agree" that an amount of time, of some particular duration, has passed as the strip is read from left to right (and down the page, if necessary). It is up to the writer and artist to communicate to the reader just how much time passes between each frame. There are several ways this can be achieved.

The simplest method, used most commonly in such humorous newspaper strips as *Peanuts*, merely allows the unfolding of a conversation between two or more characters to show the reader that time is passing. We assume that there is not a 10-minute lapse between each exchange of dialogue, unless told otherwise. However, in comic books, especially in longer stories, all kinds of tricks can be employed to convey the passing of time to the reader. Further, time can be speeded up, slowed down or made to stand still. Some of the illustrations shown here demonstrate how comics can be used to manipulate the reader's time-frame.

**Below:** With the gag strip, the joke itself is far more important than the technical quality of the drawing. This *Beetle Bailey* strip is by Mort Walker. **Bottom:** With the story strip, however, the story and art become equally important, as seen in this *Modesty Blaise* strip.

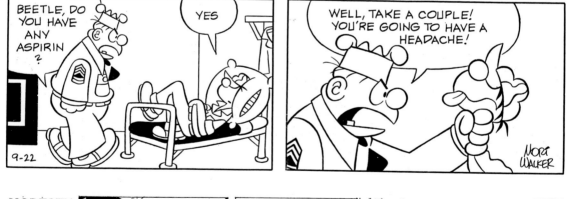

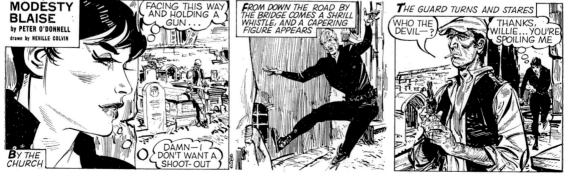

## The format
For our purposes, the comic strip can be split up into several different types.

● *The gag strip*: The single-tier humorous newspaper strip. Examples of this type include *Garfield*, *The Wizard of Id* and *Blondie*. Gag strips come also in a "Sunday" version: this used to be a full page, but is now usually limited to three tiers.
● *The story strip*: The single-tier adventure newspaper strip. Examples include *Modesty Blaise*, *Steve Canyon* and *Dick Tracy*. As with the gag strip, the story strip has a Sunday cousin, which has likewise been reduced to three tiers these days.
● *The comic book*: The standard US comic-book format is that of a 20-page story printed in four colors in a newsprint magazine of 32 pages plus covers. There are variations in book-length and paper-quality, peaking with "graphic novels" at the trade-paperback end of the scale. In the UK and Europe, the general rule is to have several episodic strips in one comic "paper," which is usually printed monochrome or two-color; there are assorted paper-qualities.

The comic book is a good deal more complicated to analyze than the newspaper strip. Within the comic-book format there are literally dozens of genres, each with its own system of techniques. Funny animal books, such as *Donald Duck*, are generally approached in a completely different way from superhero books, such as *The Amazing Spider-Man*. Then there are horror books, science-fiction books, underground books and movie-adaptation books, all of which adopt their own conventions. In addition there are the comic books that defy any kind of classification at all, like *Love and Rockets* and *Elfquest*.

## The newspaper gag strip
This might appear to be the simplest version of the comic strip – and, in some ways, it is. In most current gag strips, the drawing has been refined into a kind of visual shorthand which represents rather than depicts characters and their

**Below left:** Comic books enable the creators to tell their stories over several pages. The style of drawing used for the superhero comic shown here is more exaggerated than for other comics. Captain Britain's physical size is emphasized by the normal-sized doorway.

environments. In most cases backgrounds are merely suggested or even omitted altogether.

So the drawing component of gag strips might seem to be less important than the gag itself. In reality, however, the gag strip is a lot more difficult to analyze than we might imagine. In a strip like *Peanuts*, Schultz's attractive depiction of children and their pet beagle is a major factor in the appeal of the strip. The drawing style is simple and open, and uses few lines. Thus the art is used to *enhance* the gag it is illustrating. And, by keeping the artwork simple, the artist does not distract the reader from the real business at hand, the telling of a joke.

The gag strip is better at telling a joke than its predecessor, the gag panel. Having two or three panels in which to build up the joke, with the last panel reserved for the punchline, means that the gag strip can more closely approximate to the verbal joke as told all over the world. We have the build-up to create suspense, and then the punchline to release tension and thus produce the laugh.

As for actual drawing techniques involved... well, with the gag strip there aren't any. As long as the characters are recognizable as characters, few people care what the drawing is like.

The biggest problem in assessing the gag strip is that the style of artwork is often deceptive. While it might *look* easy to draw something as "simple" as *Peanuts* for a living, it is probably a good deal more difficult than are the more realistic styles of cartooning, for the simple reason that the artist has less lines to work with. Thus, if even one of the lines is out of place, the fault will be all the more obvious. With a realistic drawing style, more lines are used and so misdrawn lines are much less likely to be noticed.

It should be pointed out that cartoon drawing is a kind of *abstraction* from reality; that is, although reality is taken as a starting point, it is then distorted by the cartoonist for comedic effect. So, while it is possible for an aspiring cartoonist to execute acceptable cartoons without the benefit of classical art tuition, an initial knowledge of how to draw realistically is a decided advantage. You have to learn to walk before you can run and, no matter how simple the cartoon style of comic art looks, *doing* it is far closer to sprinting than is producing dramatic comic-strip art.

The only really useful advice that can be given to the novice gag-strip cartoonist is to be aware of the sort of material already in the marketplace, keep

1 The Incredible Hulk
2 Mickey Mouse
3 Spiderman
4 Alfred E. Newman

**Above:** A selection of classic comic strip characters from several different styles of comics.

3

your drawing style simple, and stick to what amuses you ... because if your work fails to please you the chances are that no one else will like it either.

## The story strip and the comic book

Both the story strip and the comic generally take a realistic approach to artwork, and with this realistic approach come all the attendant problems of figure-drawing, perspective and lighting. Within the pages of this book we do not have room to give comprehensive instruction in the techniques of representing reality in pen-and-ink, and in fact such instruction would not be of particular benefit to the aspiring comic-strip artist as anything more than a starting-point. There are many how-to-draw books available; some of the better ones are listed in the Bibliography.

In this chapter we shall concern ourselves with the rudiments of portraying three-dimensional reality on the two-dimensional page. In later chapters we shall concentrate more on the art of storytelling within the comic-strip medium.

As the most important elements of any story strip or comic book have to be characters, we will start there.

## The figure

As we have seen before the comic strip and the cinema share many storytelling conventions. One such convention states that the good guys should be tall and handsome, the heroines should be slim and beautiful, and the baddies

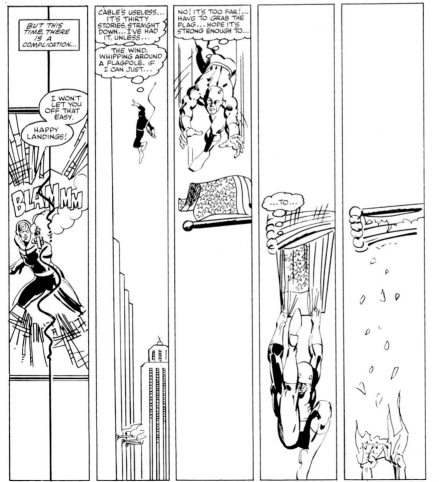

**Left:** Writer/artist Frank Miller's eloquent understatement greatly enhances the feeling of peril in this sequence from Marvel's superhero comic *Daredevil*.

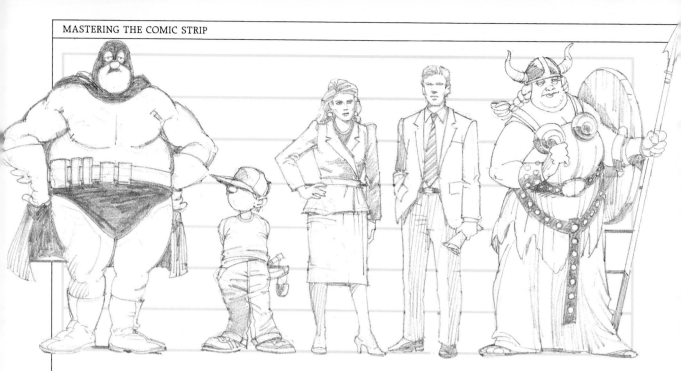

**Above:** A selection of differently proportioned human figures. **From left to right:** The superhero-type stands over seven and a half heads high, regardless of his build. Children, naturally, are shorter of stature, but notice that their heads aren't appreciably smaller. Normally proportioned figures measure six and a half heads high for women, and closer to seven heads for men. The Woman Warrior-type would stand slightly taller than a normally proportioned man.

should usually be ugly. How you portray your characters is all-important, because *characters* are what any story is about.

The average well-proportioned man stands about 6.5 heads tall. This rule simply means that the average drawn figure of a man is six-and-a-half times taller than the head of the same figure (assuming, of course, that the character is standing upright). Such a proportion is fine for innocent bystanders, the villain's henchmen and the hero's best friend. But the hero himself is always taller. Depending on what sort of a hero you are aiming to depict, the height of the figure should be somewhere between 7.5 and 8.5 heads tall. A character like Steve Canyon is drawn to be about 7 heads high; thus, if he were a real person, he would be about 6ft 4in tall. But a character like Superman, far more a creature of fantasy than Canyon, is closer to 8 heads high – making him about 7ft tall! The shoulders of male figures should be drawn to a width of about 2 heads, provided you want that rugged, muscular look.

The female figure is drawn to the same proportions, although it might be best to make the shoulders narrower. Merely reducing the size of the female head will keep your female figure marginally shorter than the male…although you may *want* your female characters to be taller.

The next difficulty encountered by most novice comic-strip artists is that of drawing the figures of their characters in convincing poses. For example, the wider apart you draw the feet, the more stable and firmly planted a figure will look. If you imagine the shape of a pyramid, a structure that is able to withstand thousands of years of exposure to the elements, and then transfer that shape to the depiction of the human figure, you will begin to see how to make a human figure seem strong and solid.

Putting your drawn figures into motion is a different matter entirely.

### The figure in motion

In order to depict a human figure in motion convincingly, it is first necessary to understand the concept of the *center of gravity*. The center of gravity of an everyday object, like a cube, is easy to determine. Simply draw intersecting lines connecting the diagonally opposed corners: the point where all three lines meet

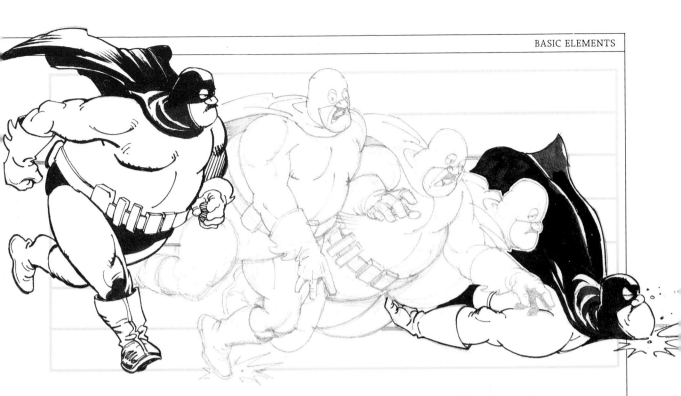

is the cube's center of gravity. It is no coincidence that this point is the cube's physical center as well.

Now, if the cube is tilted in any direction, the center of gravity can rise only while it stays vertically above some part of the cube's base; in such circumstances, when the cube is released, it falls back to its stable position. However, a point is reached where the center of gravity ceases to rise and begins to fall; this is when it passes over the boundaries of the cube's base. In this situation, a released cube will continue to move so as to allow its center of gravity to move to its next lowest position. If we repeat the experiment with a sphere, however, we see that, since the center of gravity neither rises nor falls when the sphere is displaced, there are no settling or toppling effects.

The human figure resembles the cube rather than the sphere insofar as its center of gravity (located somewhere around the groin) is concerned. If the human figure is displaced to the side, it will invariably settle back to its original position provided the center of gravity has not passed beyond the limits of the base (the feet) and begun to fall.

Applying the same principle in reverse, it is possible to make the human figure seem unstable – and thus in motion – by deliberately placing the center of gravity outside the limits of the base. By following this rule, artists can always ensure that their action scenes have dynamism, as the examples shown on this page illustrate.

### Basic perspective

If you stand in the center of a railroad track, looking along the line, it appears as if the rails meet at the horizon. Of course, in reality the rails never touch each other. What you are experiencing is an optical illusion.

Artists can use this phenomenon – *perspective* – to their own advantage, usually to put depth into their pictures. Perspective is one of the first elements discussed in any rudimentary art course. Here we shall assume you have at least a working knowledge of perspective and concentrate more on how to use perspective as a storytelling tool. Perspective and its distortion can both be used to invoke a variety of emotions in a reader.

**Above:** The stability of the human figure depends on the positioning of the center of gravity, located somewhere around the groin area. As long as the center of gravity remains inside the parameters set by the feet, the figure is stable. But if it moves outside the boundaries of the figure's feet, the stance becomes progressively more unstable until, in extreme cases, disaster occurs. Artists can capitalize on this to make their drawn figures appear to be in motion.

**Above:** An example of the "worm's eye view", a strip from *Marvel* UK's *Night-Raven,* drawn by David Lloyd.

**Above:** An example of the figure in perspective, from the *Daily Mirror's Garth* strip, by Frank Bellamy. Note how the feeling of motion toward the viewer is enhanced by having the figure break out of the frame.

Perspective is used to cue the reader as to the angle from which he or she is viewing a scene. There are only three categories of angle which will affect the perspective.

- *Eye-level:* The reader is on the same level as the objects or characters in a scene.
- *Low-angle* (also called **worm's-eye view**): The reader is below the level of the objects or characters in a scene.
- *High-angle* (also called **bird's-eye view**): The reader is above the level of the objects or characters in a scene.

**Eye-level** When you show a scene from eye-level – the commonest angle used in comic-strip frames – you are giving readers the illusion that they are physically involved in the incidents depicted – which is the usual aim of a storyteller. Of course, because eye-level is the commonest angle used by comic-strip artists, its effects are minimized by overexposure, and so the eye-level angle is also the most neutral of the three. Yet the very unobtrusiveness of the eye-level angle subtly increases the involvement of readers in the story that is being told. And, when readers are involved in the story, they get to experience vicariously the emotions felt by the story's characters. (It is possible to invoke in your readers emotions *other* than those experienced by the characters, but this involves different techniques.)

**Low-angle** A low-angle view is designed to make the readers feel small compared to the objects or characters portrayed in the frame. By using this angle, therefore, the artist can make his or her readers feel subconsciously threatened or intimidated. Conversely, the same technique can be used not so much to make the reader feel smaller as to make the characters appear larger and more threatening. Marvel Comics' popular character *The Incredible Hulk* is frequently drawn from a low-angle view to enhance his physical bulk and menace. Finally, a low-angle view can be used to make an object – particularly a piece of architecture or a huge spaceship – seem even grander and larger. The effect is enhanced if the building or spaceship is loaded with surface detail.

**High-angle** The aim of a high-angle viewpoint is to make the readers feel separated from the scene at which they are looking. It is very useful for *establishing shots* (comic-strip panels, usually the first of a new scene, which *establish* in the readers' minds exactly where they are and what they are looking at – the same technique is used in just about every movie you will ever see). Thus a panoramic view of the countryside in which, say, a squad of commandos is operating would be best shown from a high angle.

However, as well as putting space between the readers and the scene they are viewing, a high-angle shot can also be made to work the other way: it can make readers feel that the characters in a scene are cut off from the rest of the world. Thus a sense of loneliness can be invoked in readers by showing a character from a high angle, surrounded by space, so conveying the feeling that he or she is without companions.

### The figure in perspective

By depicting the figure in perspective – also called foreshortening – the comic-strip artist can achieve a similar effect to that created when showing the figure in motion, but with enhanced dynamism. For, if the sense of movement is conveyed by tilting the human figure off-balance, then think of how effective the trick can be if the figure is tipped off-balance *toward* or *away from* the readers! This trick is used extensively in comic books published by Marvel Comics, and was invented by their premier artist of the 1960s, Jack Kirby. In fact,

**Above:** An example of a cube-shaped object rendered in perspective with two vanishing points – a "bird's eye view".

**Right:** An example of the circle in perspective, showing three circles, each tilted further away from us, but at eye level.

**Above:** This shows a diagram of a building rendered in perspective using three vanishing points – a "worm's eye view".

**Above:** Subdued perspective. From eye level, perspective lines in a room tend toward the horizontal and vertical.

**Left:** Perspective in Action. This drawing shows the same character from a "worm's eye view". We know the dark stranger is peeking down through a skylight because the lines of perspective are off the horizontal and vertical.

**Right:** Extreme perspective. Here we know we are looking down on both the stranger and the character because the perspective lines are now mostly halfway between the horizontal and the vertical (at 45 degrees).

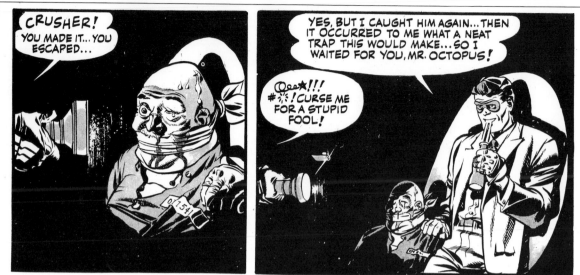

**Above:** Nobody uses light for dramatic effect like Will Eisner in his masterly 1940s comic strip, *The Spirit*.

**Below:** The position of shadows on any object depends entirely on the direction from which the prevailing light is falling, as this picture amply demonstrates.

Stan Lee's book *How to Draw Comics the Marvel Way* spends a good deal of its content dealing with this effect.

Another comic-strip trick that relies on showing the human figure in perspective is to have a character pointing either out of the frame, toward the readers, or into it. This was a trademark of the late Frank Bellamy, who drew the *Garth* newspaper strip and strip versions of Gerry Anderson's puppet television shows for a UK comic called *TV21*. The effect is that the readers' sense of depth is enhanced, making what is happening in the strip seem all the more realistic.

### Lighting

The earliest comic-strip artists acted as if they had never heard of lighting. Most comic strips, with a few exceptions such as Alex Raymond's *Flash Gordon* and Will Eisner's *The Spirit*, were drawn in a flat line style. (To be fair, this was partly due to the limitations imposed by the primitive printing techniques in use at the time.) However, with the arrival of the 1950s and the appearance of the outstanding horror comics published by Bill Gaines' EC company, lighting became a major factor in establishing mood. The idea was taken further in the 1970s by such remarkable comic-strip artists as Bernie Wrightson, the original artist on DC Comics' *Swamp Thing*, and Neal Adams, who returned *Batman* to the original "Dark Creature of the Night" concept of the 1930s.

High contrast and deep shadows provide the most effective way of transmitting feelings of the supernatural or of menace to readers. The old cliché of lighting a menacing character from below combines a low-angle viewpoint with moody lighting to give a potent, if familiar, result.

A trick favored by the late Wally Wood, who contributed many memorable science-fiction tales to the EC line of comics, was to light the human face from

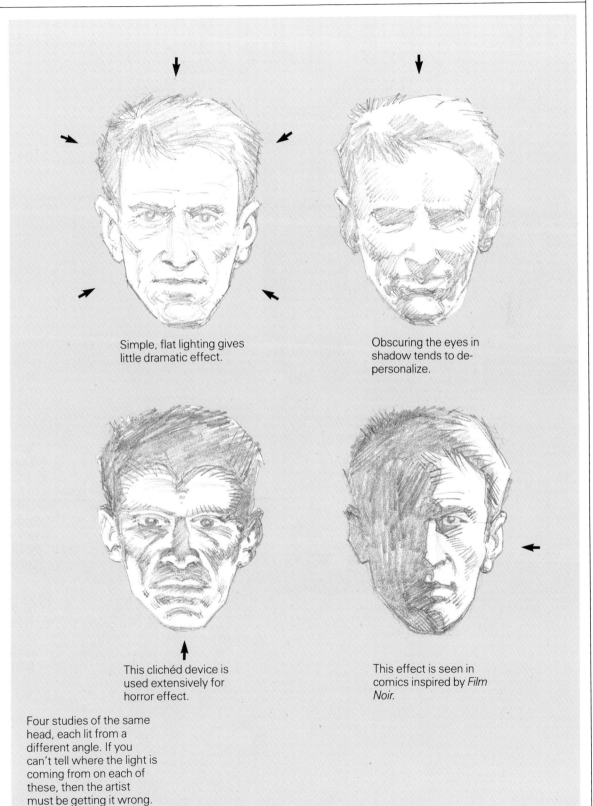

Simple, flat lighting gives little dramatic effect.

Obscuring the eyes in shadow tends to de-personalize.

This clichéd device is used extensively for horror effect.

This effect is seen in comics inspired by *Film Noir.*

Four studies of the same head, each lit from a different angle. If you can't tell where the light is coming from on each of these, then the artist must be getting it wrong.

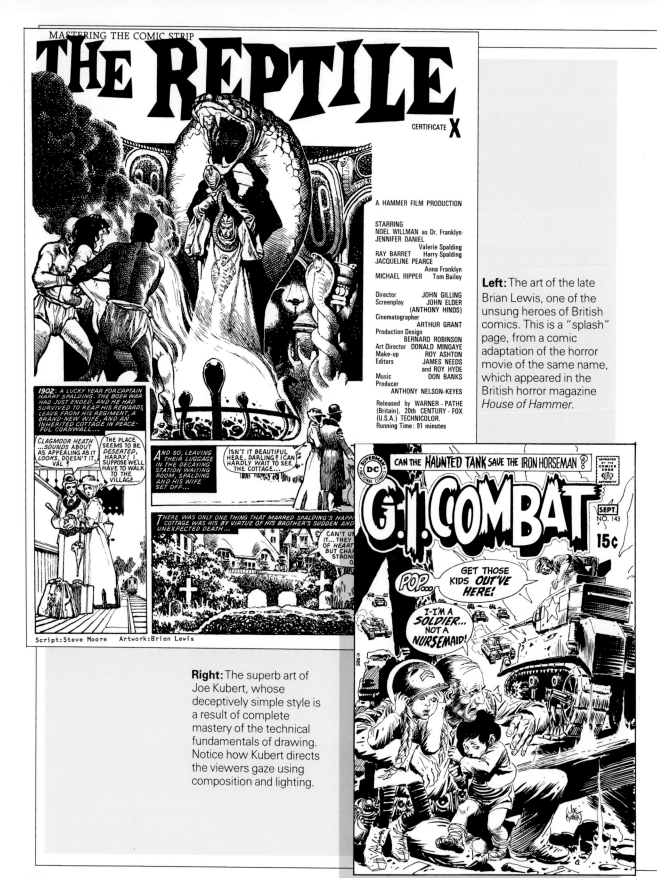

**Left:** The art of the late Brian Lewis, one of the unsung heroes of British comics. This is a "splash" page, from a comic adaptation of the horror movie of the same name, which appeared in the British horror magazine *House of Hammer*.

**Right:** The superb art of Joe Kubert, whose deceptively simple style is a result of complete mastery of the technical fundamentals of drawing. Notice how Kubert directs the viewers gaze using composition and lighting.

two separate sources. The effect was dramatic, in the broadest sense of the term, and heightened the realism of Wood's draftsmanship; however, it failed to evoke any particular emotion.

## Comic-book covers

Needless to say, an artist will only be called upon to produce covers if he or she is working in the comic-book side of the business. For covers there is a whole different way of approaching the task of drawing. A cover, like a page of comic strip, should ideally tell a story. The problem is that the artist has only a single picture with which to tell that story. As with any other comic-strip story, the protagonist is the most important element, followed by the antagonist and then by the location in which they face each other. Thus the hero in particular must have "visibility."

It has been said that you can't judge a book just by looking at its cover, but unfortunately, in reality, the cover is usually all that a potential customer has on which to base a judgement of any comic book. If you try to investigate the interior of a comic book, the proprietor of the newsstand or store will protest most vigorously that his or her establishment is not a public library. Proprietors have a point: they have a living to make.

The aim, therefore, is to arrest the potential buyer's attention with a single powerful image. The easiest, and therefore most often seen, cover formula is to have the hero battling the villain in an unusual location. A less effective approach is to pose the leading character in an attitude that would make a good poster, often with the hero being heroic or rushing toward the viewer, frequently yelling like a demented banshee. This is probably the least effective cover formula, but nevertheless is in common use.

The third approach is not seen very much these days but was popular during the 1950s and 1960s. Here the hero is shown in some kind of unusual or unlikely situation, the aim being to stimulate potential customers' curiosity and thus make them buy the comic to find out what the heck is going on. *Superman* comics of the mid-1960s used this approach very well, as did certain EC comics of the 1950s.

In the 1980s the realities of drawing comic-book covers are a little different. Very seldom will an artist – let alone a novice artist – be called upon to draw a cover "from the ground up." Covers are generally designed by the publishers' art director, often in collaboration with the editor, and then a rough pencil sketch is passed over to an experienced artist for actual execution. However, this is not to say that a comic company is necessarily closed to ideas for covers...

## Using the techniques

The best advice anyone can give to the novice comic-strip artist is to use effects like varied panel angles and foreshortening with discretion. While these techniques are effective in making dramatic points, overuse can lead to a lessening of their impact – and, in extreme cases, to reader-irritation.

The chief aim of a comic-strip artist is to *tell the story*. This is an important point that is missed even by many working professional artists. All too often, creative egos get in the way and the artwork becomes so flashy that it obstructs the course of the story. The best artist is the one who communicates the story to the reader with the minimum amount of fuss and the maximum amount of clarity.

Less is very often more.

# The Story

If there is any single thing wrong with comics today, it is the lack of good scripts. This has been a problem throughout the history of the comic strip, particularly in comic books. It seems that the script has always taken a back seat to the art. Perhaps this is because the script is the one "invisible" component of any comic strip. Anyone can tell at a glance whether a comic strip is well drawn or not, but to discern whether the script is any good takes a good deal more skill. The truth is, very few people know a good story when they see one – other than the audiences! Many people in the comics business simply cannot tell the difference between a good script and a bad one.

There is no answer to this problem, except to point out that, without exception, *the script is the single most important component of a comic strip.* Readers will tolerate barely competent art and scruffy lettering, but nothing sends a comic strip to well deserved oblivion faster than a poor storyline.

During the 1970s this simple fact of life seemed to escape most comics editors. Flashy art was in vogue. While the work of such artists as Barry Windsor-Smith and Mike Kaluta was indisputably excellent, the standard of scripts these artists were being asked to illustrate was below average. Happily, during the 1980s, the good scriptwriter has come back into style, and once again emphasis is being placed on the worth of superior storytelling.

The professional's choice. The typewriter is quite adequate but has many disadvantages. For roughly the same price as a good electric typewriter you can now buy a word processor, a device which takes the drudge out of writing.

## The script

It might seem redundant to point this out, but before an artist can sit down and draw a comic-strip story, he or she must first have a story to illustrate.

In many cases, a working artist would have a story or script supplied to him by a professional scriptwriter. More rarely, a comic-strip artist will write his or her own stories. Although there have been several outstanding writer–artists in the

The amateur's choice. It's a sad fact that manuscripts, however brilliant, will simply not be read by an editor unless they are typed. Longhand manuscripts, while good enough for English compositions and college study notes, are no use to editors.

history of the comic strip, practically none of them ever did *everything* by themselves: they all employed assistants.

Within the comics business, there are several different ways writers and artists can divide up the work that goes into producing a story in comic-strip form.

The sharpest division of tasks occurs when the artist works from a script that is solely the product of a scriptwriter. This method is favored by many major comics companies, including DC Comics in the United States and IPC Magazines in the United Kingdom, but is by no means rigidly adhered to. (However, it is the way I have always worked as a scriptwriter and it is how I have approached the stage-by-stage sample comic story we have produced for this book. The script of our story can be found reproduced at the end of this chapter.)

Another method, used only in the production of comic books, is referred to as the "Marvel method" as it is credited to Stan Lee, editor of the entire Marvel Comics line during the 1960s and early 1970s. When the company's output grew too large for one man to handle, Lee began a production system whereby he would first discuss a plot with an artist, often Jack Kirby. Kirby would then draw the story in 20 pages or so – the number of pages depending on what the current page-count of a Marvel magazine might be – then hand the pencil-drawn pages back to Lee to have the dialogue added. Lee would write the characters' dialogue directly onto the pages in pencil. The dialogue would then be lettered onto the artwork by a calligrapher, and then the pages would be inked by a separate artist. With the migration of writers and artists back and forth between all the major US comic companies, the method has spread considerably.

Another comic-book method, used during the 1950s by EC Comics but now no longer seen, was to plan the story meticulously, then break the pages down into frames (or "panels"), and then to letter the captions and dialogue balloons onto the pages before the art was actually drawn. All EC's titles, except their war comics, were produced by this method. Restrictive as this technique sounds, EC Comics are still praised to this day for their high standards of art and storytelling.

The EC war comics, written and edited by artist Harvey Kurtzman, were drawn out as page roughs, with captions and dialogue indicated. These roughs were passed on to an artist to draw full-size, before being lettered by the calligrapher.

**Below:** *E.C.*'s horror comics were often very heavy on the words: the lettering was put onto the page before the artwork, which often left the artist little room for illustration.

● *Speech balloon* A bubble containing a character's words.

● *Tail* The part of a speech balloon which points to the speaker.

● *Frame* A single illustration. Also called a "panel."

● *Bold* Words lettered more heavy than the rest, for emphasis. Indicated on a script by underlining.

● *Effect* Lettering drawn on the artwork to simulate sound. Sometimes abbreviated to "FX."

● *Thought balloon* A bubble containing what a character is thinking. Indicated on a script by "thinx" after the character's name.

**Above:** This frame from *Marvel's Sub-Mariner* comic, drawn by Jack Kirby, incorporates three of the most indispensable types of story-telling tools in comics: the standard speech balloon, the thought (or thinx) balloon and the ever-present sound effect. The "Thoom" is probably the least necessary element in this frame, because Kirby's art is quite dynamic enough without extra help from the letterer.

Kurtzman still uses this method in the production of the *Playboy* comic strip *Little Annie Fannie*, which he produces in collaboration with another veteran EC artist, Bill Elder.

There are many other ways a comic strip can be produced, depending on whether it is produced by one, two or more creative individuals, but all can be reduced to a combination of the above techniques. It is important to choose the right method for the particular style of comic strip you are aiming to produce.

### Technical terms

It is most important that the writer and the artist understand each other during their collaboration. For this reason a system of specialized terminology has become pretty much standard, with only a little regional variation. Other terms used in the descriptions of frames in comic-strip scripts are more or less self-explanatory: "close-up," "head and shoulders," "long-shot" and "establishing shot." As has been noted elsewhere, the technical terminology of comic strips crosses over frequently with the terms used in cinema. Yet, despite the superficial similarities, there are major differences between the storytelling techniques in film and comics, the most obvious being the lack of sound in comics. The advantage with comics is that the writer can be a little more subtle than in film, as the reader can always turn back a few pages and reread something he or she is not clear about, which you cannot do in a cinema.

### Limitations of the genre

Comics are a visual, not cerebral, medium. Words and ideas that would seem commonplace in a short story or novel are impossible to use effectively in the comic strip. Yet comics, like cinema and television, which also tell stories in words and pictures, are capable of some marvelous storytelling effects. And with comics, unlike film and television, it is possible to expand or contract time for dramatic effect with methods far less obtrusive than slow-motion filming. Another advantage comics have over screen entertainment is that they do not have a limited budget for sets, props and special effects. A scriptwriter can ask for a hundred thousand alien soldiers charging over a hill and get just that ... with only a muttered complaint from the artist.

On the other hand, comic strip as a medium has distinct disadvantages compared to film and television. True drama does not translate well to the comics medium. Whether this is because of limitations inherent in comics *per se*,

or more due to limitations in any comic-strip audience's attention span, is difficult to tell. Perhaps it is a little of both. But the fact remains that any comics story with a lot of talking is assumed to make pretty dull reading, as all the artist would have to illustrate would be "talking heads," the bane of any comic editor's life. If you write a scene in which there must be a good deal of talking – called "exposition" – it is always advisable to have the characters *doing* something while they talk. I have always referred to this technique as "exposition on the run"! However, what the characters are doing should have something to do with the story, or should throw light on their personalities.

The single most telling limitation on the type of story you can tell in comic-strip form is the amount of space you have in which to tell it. This may seem like a pointless observation, but it is a common mistake among beginners to try to tell *War and Peace* in a six-page comic strip. It is important to tailor your story to the space available. In this respect, a daily continuing story strip designed for newspapers is more flexible than a complete story for a comic book.

With most US comic books, the writer has about 20 pages to tell the story in. This means that he or she is required to produce a story which can be dealt with in that number of pages, rather than thinking of a story and trying to cram it into

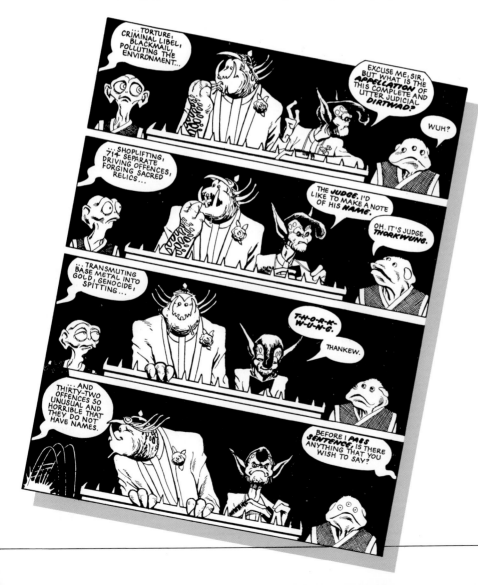

**Left:** A sequence from *2000AD*'s *D.R. and Quinch,* written by Alan Moore and drawn by Alan Davis. Note the parallel incidents. While D.R. finds out the judge's name, the even more disgusting Quinch peels a wad of bandage off his face and eats it, causing the Clerk of the Court to pass out . . .

the available space. It is possible to continue a story over several issues, and this was popular during the 1960s and 1970s, although it has largely fallen from favor today. The British format, which limits the writer to five or six pages a week, requires even more discipline, although continued stories are more popular. In certain British comics, complete stories lasting only three pages are not uncommon. Three pages of comic strip is barely enough room for an incident!

At the other end of the scale is the graphic novel. "Graphic novel" is a term used to describe a comic strip of 40 or more pages, usually bound in a large-size paperback format. It is a misleading term, because a 40-page comics story cannot even begin to approach the kind of depth found in a genuine novel. Yet graphic novels are a step in the right direction for English-language comic strip (countries such as France have been publishing what we might call graphic novels for years). And, indeed, a lot of good work has been done in this format.

**Right:** A particularly powerful piece of story – telling from Will Eisner. By using the dripping of the tap like a metronome, Eisner effectively shows a few seconds in the brutal torture of his hero, the Spirit.

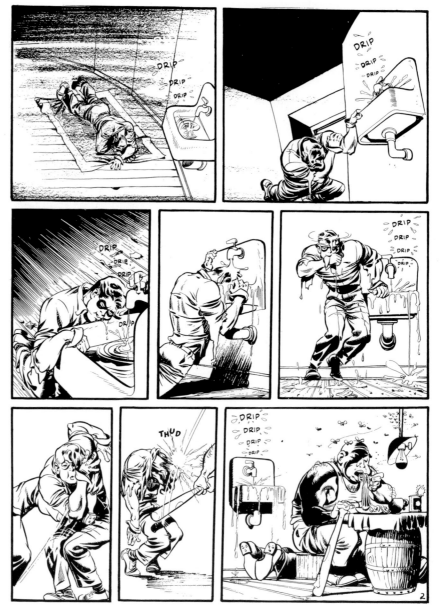

**The story**

What is a story? This is not an easy question to answer. It has been said that every story should have a beginning, a middle and an end, but this tells us nothing. It would be better to say that a story must first introduce the setting, then the characters, then it should put those characters in some sort of conflict, thus producing drama, and finally the conflict should be resolved by the characters themselves.

Yet even this is not enough. A story should have something to *say*. Despite movie mogul Sam Goldwyn's assertion that those who want to communicate a message should call the Western Union, a story is not a story unless it makes some kind of observation about human nature. This observation we can call the *theme*. When you have decided what the theme of your story is – it could be jealousy, for example – you can move on to creating the plot.

The *plot* of a story is the depiction of the drama and its resolution. While the plot is separate from the theme, it is often motivated by emotions underlying the theme. Thus the plot of your story could be about the solving of a murder mystery. That the murder was motivated by jealousy makes an observation about how far a human being can be pushed by such emotions. Not startlingly original, but you get the idea.

In unfolding the plot, your main aim is to convince your reader that what follows is the truth, is real. This you do by creating such a convincing world that he or she has no alternative but to *suspend disbelief* for the duration of the story. That is, though the readers know they are reading a story, they temporarily enjoy the sensation of experiencing what the characters in the story experience.

To achieve this, the first order of business is to establish the background against which your story will be told. How well you establish this background in the reader's mind will affect the degree of success of your story. The idea is to convince the reader that he or she is actually experiencing the background you have created. For example, you might want to tell your story against a background of the Russian Revolution. How well you evoke 1917 Russia will be crucial to the reader's suspension of disbelief.

Next, you need to establish the identities of the protagonist (the good guy), the antagonist (the bad guy) and the supporting characters. Much of the success of your story will stem not from how realistic your characters are, but by how likable they are – even the villains! When we turn to popular fiction for relaxation, we are not looking for a mirror-perfect depiction of reality, but rather a simplified and ordered view of the world, in which Good triumphs and Evil is defeated by the virtuous. Nowhere is this more true than in comics.

In the telling of your story, it is necessary to tell it from one character's point of view. This gives the story a focus. It is common to use the protagonist as the story's focus, although it is possible to use instead the villain. A useful hint here is to limit the use of thought balloons to the character you have chosen to represent the point of view. (Personally, I think thought balloons are a crutch for lazy comic writers. I try to avoid them wherever possible, and, when I cannot avoid them, I try to restrict them to the protagonist(s) of a particular story.)

It has been said that a story is created when subplots cross over with the plot and with one another. For example, the plot might be Captain Aluminum's battle to the death with the Human Spin Dryer; the subplot might be the Captain's deteriorating relationship with his secretary, Judie. The crossover comes when the pressure of the stale romance affects the Captain's fighting abilities in the final battle with old Spinny. In comics, you need 10-12 pages to tell a story which uses subplots. Certainly, subplots avoid reader-boredom, providing both the protagonist and the reader more to worry about.

AGATHA CRUMM ®                By Bill Hoest

HOW DID NEGOTIATIONS WITH THE UNION GO, AGATHA?

BETTER, C.F. THEY REDUCED THEIR DEMANDS...

...FROM **INTOLERABLE** TO **UNREASONABLE!**

8-7

HOEST

**Above:** The standard three-frame gag strip. The formula is simplicity itself: frame 1 (the establishing shot); frame 2 (the gag is set up) and frame 3 (the punchline). The effectiveness of the formula depends entirely on the wit of the creator.

## Newspaper strips

There is nothing anyone can teach you about writing for a three- or four-frame gag strip in the style of *The Wizard of Id* or *Peanuts*. Either you have a talent for that type of writing or you don't. But the formula works best in four frames and consists of an introductory frame to establish the scene, followed by an event, or a statement that affects the protagonist, then the protagonist's response to the event or the punchline, finally followed by the effects of the punchline. This formula has been around since the beginning of gag strips in newspapers, and was used for years by George Herrimann for *Krazy Kat*. It is not the only way a four-frame gag strip will work, but it is about the most reliable.

There are two distinct ways of approaching series gags, both of which are ideally suited to the format of the newspaper gag strip. The first of these is to use a series of linked gags which tell an on-going story. Walt Kelly, creator of the gag strip legend *Pogo*, used this idea to a devastating effect and, nearly twenty years

**Right:** A series of consecutive dailies from Frank Dickens' *Bristow* strip. Note how Dickens uses the basic idea of dieting to provide several variations on a theme and milks the gag for all it's worth.

Bristow: Frank Dickens

WELL, JONES — I'VE SPENT THE WHOLE WEEKEND DIETING AND EXERCISING — WHAT DO YOU THINK?

GIVE US A TWIRL.....

MMMH!

PIROUETTE! PIROUETTE!

WELL?

TIE A STRING ROUND YOUR WAIST AND FASTEN IT TO THE CHAIR BEFORE YOU SIT DOWN... WE CAN'T HAVE YOU FLOATING AWAY.......

6874

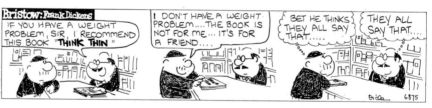

Bristow: Frank Dickens

IF YOU HAVE A WEIGHT PROBLEM, SIR, I RECOMMEND THIS BOOK "**THINK THIN**"

I DON'T HAVE A WEIGHT PROBLEM....THE BOOK IS NOT FOR ME.... IT'S FOR A FRIEND....

BET HE THINKS THEY ALL SAY THAT......

THEY ALL SAY THAT....

6875

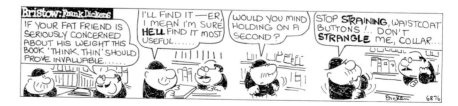

Bristow: Frank Dickens

IF YOUR FAT FRIEND IS SERIOUSLY CONCERNED ABOUT HIS WEIGHT THIS BOOK 'THINK THIN' SHOULD PROVE INVALUABLE.......

I'LL FIND IT —ER I MEAN I'M SURE HE'LL FIND IT MOST USEFUL......

WOULD YOU MIND HOLDING ON A SECOND?

STOP **STRAINING**, WAISTCOAT BUTTONS !... DON'T **STRANGLE** ME, COLLAR...

6876

earlier, Floyd Gottfredson also used this concept brilliantly in his *Mickey Mouse* daily strip.

The other approach to series gags is to use a situation or an object around which to build a succession of "variations on a theme." Charles Schulz' *Peanuts* will often use this technique as the basis for a week's material. In extreme cases, the whole run of a gag strip can be built up around a single situation, for example, Frank Dickens' office workers strip, *Bristow*. The best way to learn how to do this is to study examples by the best strip creators, and we have included some examples here to start you off.

The daily story strip is another thing entirely. To begin with, a strip editor will want to know the entire storyline in advance and often will also want to know exactly how many episodes the story will take. Having taken care of that detail, the scriptwriter must then tackle the almost impossible task of holding a reader's attention from day to day while a story unfolds, often over several months.

The writing of a single episode should be an exercise in economy. In the space

**Left:** A startling page of artwork from one of the best draftsmen to emerge from British comic books, Brian Bolland. This strip is from a *Judge Dredd* story in the British comics success story, *2000AD*.

**Right:** The main strength of Charles Schultz's work is the biting observation of his writing, which is further highlighted by the deceptive simplicity of his drawing.

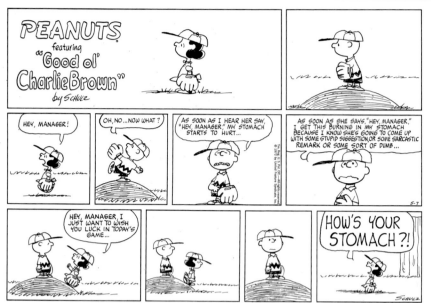

of three or four frames, the writer must establish the scene for a reader, tell some of the story, then end on a cliffhanger to bring that reader back the next day – or, more difficult, on Monday – to take up the story once more.

It is at the same time a very restrictive and very demanding format to write for. The best practical advice a beginner can receive is to study some of the many volumes of collected daily comic strips available, to see how other writers have used the format. Collections of many of the best newspaper adventure strips include *Terry and the Pirates*, *Flash Gordon* and *Garth*. Suppliers of this type of material are listed in the appendix.

### Comic books

Comic-book stories come in a variety of sizes. In the "funny" books, typified by *Archie* comics in the United States and *The Beano* in the United Kingdom, it is not unusual to find complete stories which run to only one page. These are usually gag strips of six or more frames. In the United Kingdom, comics tend to favor eight or more frames on a page, whereas in the United States, with a smaller page size, six frames on a page is a more common average.

In adventure comics, stories of three or more pages are the rule. In a three-page story, the writer barely has room to introduce the characters and then to set up and resolve the conflict. There is no space for subplots, for characters who do not move the plot forward, or even for characterization. Just the plot. Luckily, there is little demand for complete comic-strip stories of only three pages.' Readers demand more, and get it. Editors of comics in the United States, the United Kingdom and Japan commission lengthy serials in an effort to bring their readers back, week after week, month after month. In Japan, especially, these serials may run for years and add up to hundreds of pages.

### Write comics!

There are many different ways of getting your comic-strip script down on paper, the only requisite being that, apart from being *good*, the end result should also be typed.

As it is not possible to tell anyone how to think up stories, I can only describe how I came to write the sample script at the end of this chapter. I was having some problems trying to think of an idea that would work effectively in two

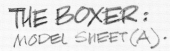

# THE BOXER:
## MODEL SHEET (A).

A model sheet for the characters who appear in *The Rose.* A model sheet is used as a kind of handy visual guide to the general look of the characters in a comic strip. An artist should submit a model sheet for the characters he has created to the editor who then uses this visual teaser to "sell" the strip to everyone else involved.

A HARD, STREET-FIGHTING MAN — BUT SEEKING A WAY TO PUT HIS SKILLS TO GOOD USE—

MAI-LIN — DECEPTIVELY GENTLE.

JAPANESE LADY.

BODYGUARD.

pages, all the space we could spare. (Not that a two-page comic-strip tale is impossible – I once scripted a two-page comics adaptation of the opera "Carmen"!) Then, after a few weeks of struggle, I was watching a Gene Kelly musical on television. One of Kelly's ballet routines he frequently inserts in his pictures was unspooling in glorious technicolor before my eyes when it occurred to me that two pages of comic strip are similar to a ballet vignette, and I began to play around with an idea where a circus clown is given a flower by a beautiful trapeze artiste. The girl then falls from her perch. In shock, the clown drops the flower and rushes forward. But the girl is dead. As she is carried away, the clown sadly picks up the flower, by now crushed into the sawdust.

As you can see, it is just the sort of thing Gene Kelly might do! So much so that I knew it was too corny. Yet the same idea might seem better if I told it against a more unusual background. For some reason, I thought of the excellent Japanese movie *Rashomon*, in which a samurai and his wife are attacked by a bandit. How about I make my protagonist a witness to a robbery and the victim a beautiful samurai woman? The idea seemed to be getting somewhere.

After a little deliberation, I decided to use a character that I had already worked on with professional comic artist Steve Parkhouse. Our character, The Boxer, was an attempt to do a realistic martial-arts character in comic-strip form. By setting it in 1899 in mainland China, just before the Boxer Uprising, we effectively had a man of action in a lawless environment, a parallel to the cowboy of the old West. So The Boxer would witness the robbery and death of a beautiful samurai woman. What we would have would essentially be a character piece in which the senseless death of the Japanese lady could be compared to the restrained violence of the protagonist, a trained fighter. And I tried to keep the motif of the crushed flower in there. Ambitious for two pages...

From here it was simply a matter of putting the story on paper.

As I use a word processor, I have no problems with having to produce longhand drafts, then typing them up. I just bash the script straight down onto the machine,

**Below:** Ex-Disney animator Floyd Gottfredson was the key *Mickey Mouse* artist of the 1930s. However, he also wrote some of the stories.

then go back to the beginning and rewrite a few times. How many times you rewrite depends on how much time you have and whether the script really needs another run-through.

Generally, I start at "Frame 1" and push on through to the end, allowing between six and eight frames per page. Many writers just allot the approximate number of frames and leave the artist to sort out how the frames fall on the page. Personally, I prefer to pace the story a little more and indicate to the artist where I think the page-breaks should be. Thus, I can write scenes which last for an exact number of pages. I hate scene changes to occur halfway down a page, or worse, one frame from the beginning or end of a page. In a way, this is also adding the chore of breakdowns (see next chapter) to the writer's job, and some artists may object to this, but it works for me.

If you turn to the sample comic-strip script at the end of this chapter, you will see how the instructions for each frame are laid out. First, the picture to be drawn in the frame is described. How much detail the writer gives the artist is a matter of commonsense. Personally, I think the writer should mention only what is necessary for the plot and let the artist add local color, and so scene-descriptions are kept to a minimum. The only frame which is different in this respect is the first. In the scene description of Frame 1, I like to give the artist some background information, describe the major characters in detail and try to convey to the artist the general "feel" I have in mind. Some writers prefer to give this information on a separate sheet.

As you read through this script, you will see that the story begins with the protagonists, The Boxer (who is never named in the strip) and Mai-Lin arguing good-naturedly over the pros and cons of commercialization. Even in the first frame we establish the presence of the Japanese woman and the flower. The scene is shattered when the Japanese woman is knifed and her bodyguard fails to protect her. The Boxer then intervenes. The bodyguard, crushed by his failure, seems to be a broken man. The Boxer picks up the slightly crushed flower and gives it to Mai-Lin.

For me, there are all sorts of references and resonances in this little incident, although it is unlikely that a reader would be consciously aware of them. Yet there is an implied relationship and similarity between the Japanese characters and the two Chinese protagonists. And the crushed flower is a symbol for the victim of the senseless violence we witness.

All of this works better if the reader is familiar with The Boxer and his world. However, in isolation, this is merely an interesting exercise in portraying an incident which is European in style and oriental in content ... a curious hybrid.

On these pages the actual typescript of *The Boxer* story is illustrated to give an idea of how a comic strip script is laid out. Note that with the frame descriptions, clarity rather than literary quality is the aim.

---

Sheet 2.

Mai-Lin: I <u>love</u> markets. The smells, the sounds! It's so exciting!

Boxer: They encourage vermin! That makes them <u>dangerous</u>.

Frame 2

The Boxer and Mai-Lin are level with the mouth of the alley. Just inside the alley, in the shadows, an unsavory-looking character lurks furtively.

Mai-Lin: Vermin? Wah! Always so serious. It's <u>market</u> day.

Frame 3

Now we're inside the alleymouth. The furtive character, a mugger of no fixed name, peers out into the square, where the beautiful Japanese woman is completing her transaction with the flower vendor. The bodyguard stands a little distance away.

Caption: Let's have <u>fun</u>.

Frame 4

The Boxer and Mai-Lin stroll toward us. Behind them, the mugger has stepped out of the alley, a knife in his hand, and is taking the first step of a run toward us.

Boxer: I'd rather <u>eat</u>!

Mai-Lin: Well ... <u>only</u> if we have <u>dim sum</u>* in a big restaurant. I'm tired of quiet, wayside inns!

Footnote: * Chinese dumpling lunch.

Frame 5

The mugger rushes past our heroes, jostling Mai-Lin off-balance as he shoves past her. The Boxer is steadying her and calling out angrily to the rude fellow. He doesn't notice the knife in the mugger's hand.

Boxer: Agreed – <u>hey</u>!

Mai-Lin: Unhh!

---

THE BOXER STRIP

Frame 1

A market square – one of many – in the market town of Hengfeng, mainland China, 1899.

The general scene in this largish frame should be one of business as usual. Traders bawl out their wares to the thronging passers-by. There's all sorts of stuff for sale, from jewelry to those flattened roast ducks you see everywhere there's a Chinese community.

In the foreground, an absolutely beautiful Japanese Samurai woman smiles with pleasure as she buys a particularly fine white rose from a vendor. Try to include the lady's tough-looking Samurai bodyguard (Yojimbo!) nearby, hand on sword, looking tough.

In the background, center-frame. The Boxer and his traveling companion Mai-Lin stroll through the crowd. Let's not have too much of a crowd around our protagonists, or we won't be able to focus the reader's attention on them. Though they're in the background, they should still dominate the frame. Behind them, a wall of a building. Ahead of them, an alleyway between this building and the next.

The Boxer, our hero, is not particularly heroic-looking. He's a wiry, slightly battered-looking kung-fu fighter. His short black hair is kind of spiky and his face has the look of a working-class Chinese man of about 25. You should suggest a bit of muscle around his shoulders, but he weighs only about 135 lb.

Mai-Lin is a blind Chinese girl of about 21. Her hair is bobbed and her eyes are blank white. She is attractive, despite her strange eyes. She wears a Chinese pajama-type suite and carries a slender pole about 5 ft long which she uses as a cane to test the ground ahead of her. In reality, she needs no cane: this is a weapon. She uses it both as a pole and as a bow, for Mai-Lin is also an accomplished martial artist.

They chat.

Caption: Hengfeng, Spring 1899. In the bustle market day, most eyes are on a beautiful Japanese Samurai woman.

Caption 2: Nobody notices a scruffy traveling fighter and his blind companion, Mai-Lin.

---

Sheet 3.

Frame 6

Same angle on t
include the Ja
paying the ven
The mugger rus
even in shot.
this very cru
In the backgr
feet again, a

Caption:

Frame 7

The mugger
with one h
held in t
out of sw
happening

Caption:

Woman:

Frame 8

This i
toward
angui

Body

Fram

Est
Box
The
as
ba
di
m
i

Sheet 4.

Frame 10

The Boxer has grabbed the mugger's knife-hand, with a straight-arm claw lock on the mugger's wrist. With this lock, he holds the knife-arm out to the side, away from them both. His other (right) hand delivers a powerful palm blow to the mugger's sternum. The effect is like the mugger was hit in the chest with a wrecking ball. His feet have lifted off the ground and every last breath of wind whistles from his body.

Mugger:    Whuff!

Frame 11

Similar angle to the last frame. The Boxer holds his guard's position. The mugger squirms gasping on the ground at the Boxer's feet. The Samurai bodyguard has entered the frame, sword held high. He gapes down in disbelief at the mugger.

Caption:    Unless vermin are crushed on sight ...

Bodyguard:    Aah!

Frame 12

The Japanese bodyguard, still standing over the mugger, drops his sword to the ground. His shoulders slump, like this is the very worst day of his life. In the background, Mai-Lin reaches out to touch the Boxer's arm. The Boxer cannot tear his eyes away from the bodyguard, understanding a little of what the bodyguard's going through.

Caption:    ... without hesitation ...

Mai-Lin:    What's happening?

Boxer:    It's all right, now. It's over!

Sword(fx):    CLNNTCH!

Frame 13

In the foreground, the bodyguard walks away from the fallen mugger and the Boxer and Mai-Lin, in the background. He's walking toward the reader, his whole body posture says "despair"!

---

...evious scene but pulled back to
...e woman in the foreground. She is
...ith a coin from a pouch-type purse.
...p behind her. The bodyguard isn't
...t to get across the idea that in
...instant, he's not paying attention.
... the Boxer has set Mai-Lin on her
...eems concerned about her.

...ike all vermin, market rats come out
...of the shadows only when they're
...hungry ...

...s the purse away from the Japanese woman
... stabs her in the back with his knife
...her. The bodyguard, in shot now, but
...ange, reacts in horror to what is
...s sword already half-drawn.

And when hungry, they are at their most dangerous ...

Aghh!

...lit into two, as the Samurai bodyguard rushes
...sword drawn, screaming like a banshee,
...d horror all over his face.

YAAAAAAAAAAAAAAAAAAAAA ...

...shing shot, from a lower angle, showing the
...nd Mai-Lin in the background.
...r is pushing Mai-Lin (gently!) away from him
...prepares to take out the mugger. The mugger rushes
...oward them, or rather, toward the alleyway
...ly behind them. The bodyguard lurches after the
...: In the foreground, the Japanese woman lies
... puddle of blood.

... AAAAAAAAAAAAAAAAAA!

...guard:

---

Sheet 5.

Caption:    ... they cause despair ...

Frame 14

In the foreground, the Boxer's hand picks up the flower the Japanese woman had bought. It's a bit crushed now. In the background, the bodyguard kneels beside the body of his mistress, his head bowed.

Caption:    and destroy everything of beauty.

Frame 15

The Boxer's hand holds our the flower. Mai-Lin's hands cup the petals tenderly.

Mai-Lin:    But there was a fight - Why, it's a flower!

Boxer:    Yes, it deserves better care than the Samurai gave the lady who bought it...

Frame 16

The Boxer and Mai-Lin move off, leaving the bodyguard standing over the body of his fallen mistress. A small crowd is beginning to gather around the Japanese; Perhaps we should angle this final scene like we're looking down on it.

Mai-Lin:    But I don't understand ...

Boxer:    Never mind, let's eat. And afterward, I'll tell you the whole sad story.

Footnote:    End.

# The Breakdown

**Opposite:** Here the layout can be compared with the final comic strip as lettered and drawn by Steve Parkhouse. The layout is really only the roughest guide, and changes will occur as the images solidify on the page.

While the breakdown of a story into comic strip is a definite stage in the creative process, it is a chore that can be executed by (a) the writer, (b) the artist, or (c) both, depending on the writing techniques employed. With the full-script method, much of the breakdown is in the hands of the writer, because the contents of each panel are set down in the script, sometimes to the extent of describing whether a panel should be close-up or long-shot, high-angle or low-angle, large or small. Only the placement of the panels on the page is left to the artist.

On the other hand, if the artist works from a synopsis supplied by the writer, as with the "Marvel method," much of the breakdown is left to the artist, although some writers who use this method give indications to the artist in the way they write the synopsis. The commonest way of doing this is to use one sentence to describe a panel and one paragraph to describe a page. Thus, each paragraph has the same number of sentences as the comic page will have panels.

When it comes to the mechanics of deciding what will be shown in each panel of a comic strip, it is useful to use movie analogies. In a strip of film, the viewer is shown 24 frames per second – too fast to distinguish individually – and is given the illusion of continuous movement. With comics, the rate at which the frames pass the eye is a good deal slower. Thus, the reader is required to fill in what happens between comic panels with his or her own imagination. It is the writer's and the artist's job to supply the reader with a stream of panels which show selected highlights from the action of the story. The selection of these highlights forms the core of the breaking down of a story. Whether this job is done well or badly is crucial not only to readers' enjoyment of the story but also to their very understanding of it. So the breakdown must have *clarity* as well as *creativity*.

## Breaking down the story

It should be remembered that the comic-strip panel is designed to contain the dialogue which the characters speak as well as the actions they make. Thus, breakdown of a story into panels depends quite heavily on how the dialogue is written.

A good rule of thumb is to arrange it so that there is only one exchange of dialogue (a character's speech and another's reply) per frame. As speech balloons should contain no more than about 20 words, no frame should contain more than a total of 40 words. This is not a rigid rule, and it is broken all the time by professional comics people, but these word-counts should be treated as an upper limit to keep your comics from being too "wordy."

Then there are going to be many frames which contain no dialogue at all. Never be afraid to have panels in your comic strip with no words: some of the best comic strips work because they have no words. When I was working as an editor at the London office of Marvel Comics the company was publishing a character called Night-Raven, scripted by Steve Parkhouse and drawn by David Lloyd. The artwork for one episode came back to our office for lettering. Looking through the three-page story, I was impressed to see that Lloyd's artwork

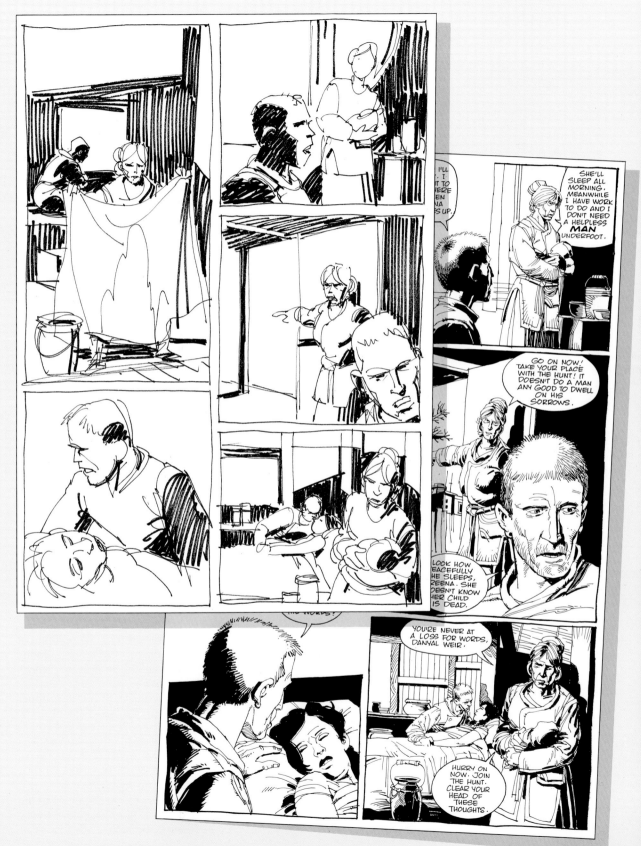

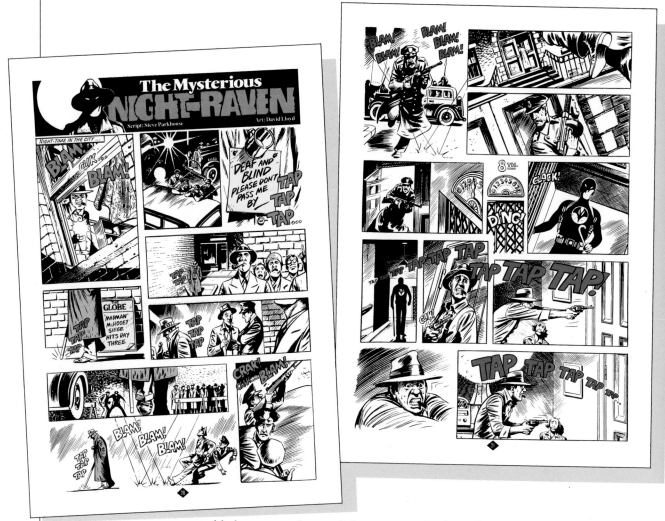

enabled me to understand the story perfectly without the benefit of word balloons. Looking over the script, I saw that Parkhouse had asked for very little dialogue, and what he had asked for was unnecessary for the understanding of the story. So I suggested to the editor of the strip that the three-pager be run as it was, without lettering. And that was how it finally appeared. Of course, the other editor might have taken to my suggestion because he saw it as a way to save himself the cost of three pages of lettering, but I like to think it was because he saw that it gave the story more impact to run it "silent."

Another consideration is that, as far as the reader is concerned, the time-span of your story is purely subjective. That is, the action in a comic strip occurs at the same speed as your audience reads it. So you don't want action sequences cluttered up with dialogue or captions. Words just slow the action down to a snail's pace.

A warning to any comics professional about the danger of too many words is the story of an old-time artist who saw a boy reading one of his comics in a barbershop. He watched the youngster for a few moments before realizing that the child was reading only the top tier of each page. He took it upon himself to

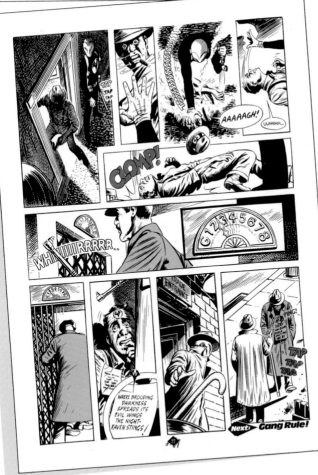

explain to the boy that he should read the whole page to get the full flavor of the story. The child replied: "I know, but it's quicker this way!" The artist's reply is unrecorded.

## Symmetrical pacing

Symmetrical pacing is a name I have given to the way some cartoonists approach their storytelling. I first noticed this while reading a *Donald Duck* comic written and drawn by the great Duck man himself, Carl Barks. It occurred to me that each of Barks' meticulously drawn pages could be divided into a top half and a bottom half. Each of these halves was a self-contained unit, like a two-tiered newspaper strip. Yet these stories were created exclusively for the comic books. Within the halves, Barks varies the layout of the panels wildly, but rigidly maintains the halfway, dividing gutter. Most of these half-pages are self-contained gags that stand up on their own, yet form an integral part of the story Barks is telling. At the same time, almost any one of these half-pages can be removed from the story without seriously damaging the flow.

It is possible that Barks used this technique to enable an editor to reduce the length of the story easily when it came to presenting it in different formats. Or, more likely, perhaps it enabled the comic books editors to remove scenes which failed to meet with the approval of the Disney Studios. Weight is added to this latter argument by the panels reproduced here. These panels never appeared in the story as printed in the comic book at the time, and are shown here for the first time.

## The panel

The decision as to which instants of the action to freeze into comic panels, how to frame them and how large to make each panel is largely an instinctive one, and is the product more of commonsense than of know-how. The size of the frame should relate to the importance of the action depicted in the frame. Generally speaking, the larger the panel, the more important the action.

For example, imagine you want to show a man fixing a watch, then fumbling and dropping the mechanism to the floor, where it smashes. The sequence could be shown in three frames – the man working, the fumble, and the impact of the watch on the ground – yet it could be enhanced considerably by adding one or two more frames. If you showed the man holding up the watch in satisfaction after he finished working on it, it would make the subsequent fumble and destruction of the watch more ironic. And, by adding a panel of the man's reaction to the watch smashing on the ground, you could increase the reader's sympathy for the watchmaker and give the incident pathos. In this way, the breakdown itself influences the emotions the story provokes in the reader.

**Opposite:** In this page from a Carl Barks *Donald Duck* story, the story breaks in half quite naturally. An examination of almost any Barks Disney story reveals that this was normal practice, probably to facilitate easier editing.

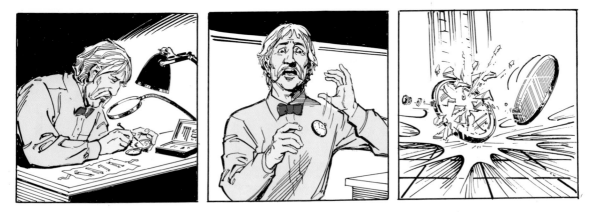

What the watchmaker is saying or thinking (the responsibility of the writer) is another set of influences on the reader, and how each separate panel is framed is also a major influence.

For example, the first frame needs to show enough to let the reader know what the watchmaker is doing. Thus it should be at least a mid-shot, showing the character's face, his hands, the watch, and his workshop surroundings (a long-shot would be better, showing the character's full figure). The second panel, showing the watchmaker's pleasure at finishing his work, holding up the watch, could be closer in, showing head-and-shoulders. Pull back to a mid- or long-shot for the third frame, showing the fumble and the watch falling. The

*The Tale of the Clumsy Watchmaker.* **Above:** This version, with its lack of human content, merely relates the incident and no more. **Below:** This is more like it. Here, the artist has added emotion and thus is telling a story.

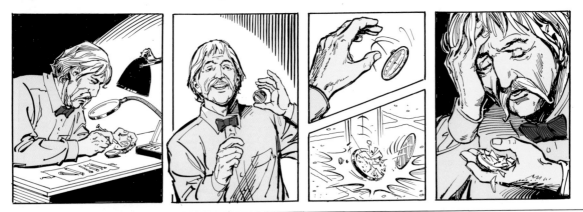

**Below:** Artist Alan Davis repeats a series of frames with minimal changes to stretch a piece of action out for dramatic effect. This strip is from *D.R. & Quinch Go To Hollywood* which appeared in IPC's *2000AD.*

**Bottom right:** The magic of Frank Miller. In this extract from *Daredevil,* the dialogue tells you that the blind hero has to defend himself against the deadliest assassin of all, *Bullseye,* but it's the design that convinces you.

fourth frame could be a close-up of the watch smashing to pieces on the ground. The final frame could have the character's expression as its center of focus. Then again, it could be better to have the scattered pieces of the watch in frame so the reader knows what the watchmaker is upset about. Thus it might be a better idea to convey the watchmaker's emotion by using his "body language." So you could frame the last panel from a high angle, showing the watchmaker's full figure, shoulders slumped in dejection, head bowed, with the mess of cogwheels at his feet.

The idea is to get *variety* into the way in which you present the sequence. So it is best to make sure that you do not create a sequence that is all close-ups or all long-shots. Even an expository conversation between two characters can be given variety – in the same way a film director would do it: by cutting back and forth between the characters, dropping in a two-shot (a frame that shows a head-and-shoulders close-up of both characters), and so on.

On the more mechanical side, the way the panels' borders are drawn can be used to convey certain feelings to the reader. The standard rectangular panel border is the most used and therefore the most neutral. A cloud-like panel border indicates that what is shown is in some character's imagination, or is part of some character's narrative. A jagged panel border conveys impact, noise or

violence. A wavy panel border can indicate events in the story's past or future or in a separate reality; e.g., a parallel dimension. Having no panel border at all is useful at the emotional highpoints of a story.

"Objectifying" the panel borders – that is, making the panel border the floor or wall for a character in the frame – can be effective, although Jim Shooter, Editor-in-Chief of Marvel Comics in New York, is said to dislike the practice. Another related trick is to show a character overlapping the boundaries of the frame drawn around him. This gives the figure impact and motion out of the page toward the reader.

It is also possible to draw the panel border in novelty shapes. Will Eisner, writer-artist of *The Spirit*, has used panel borders shaped like windows, cave mouths, doorways, and even human eyes.

Then, adding gutters to a single large frame can give two opposite effects. Simply adding three vertical gutters to a single wide frame can convey to the reader that time is passing. This effect can be enhanced by progressing some kind of action in each of the four subframes. For example, a single wide frame could show a hospital room, a figure sitting at panel-left, head in hands. The foreground across all four subframes could be a figure in a hospital bed. At frame right could be a window through which the sun can be seen rising. If the artist grades the light from left to right as dark to light, the feeling conveyed is that the character has kept a vigil all night over the bedridden figure.

The other way to use this "extra gutters" technique is as demonstrated by writer-artist Jim Steranko in a Captain America story in which he had Cap turn away from the injured figure of Rick Jones, his teenage partner, showing the

**Above:** The final frame from a Winsor McCay *Little Nemo in Slumberland* strip. Here McCay uses the old standby of a circular frame within a larger frame. The effect is like that of a large full-stop.

**Right:** In this tightly-packed page Alan Moore, ably assisted by Mike Collins and Mark Farmer, manages to savage the highly regarded Miller version of *Daredevil,* the blind superhero published by *Marvel* Comics.

THE LONG, HARROWING DRIVE HAD MADE THE COUPLE EDGY! NOW, AN ICY WIND BLEW ACROSS THE WATER, WHISPERED TO THEM AS THEY BEGAN TO ASCEND THE STEPS, CUT INTO THE VERY FACE OF THE BLEAK ROCK!

MARIE WONDERED HOW IT COULD EVER HAVE BEEN BUILT OR WHY THE WIND HAD NOT TOPPLED IT FROM ITS LOFTY AND FORLORN PERCH!

FROM ITS BASE THE CLIMB SEEMED LIKE AN ETERNITY AS IT WOUND AN ANGULAR PATH EVER UPWARD!

AND, ABOVE THEM, SHADOW HOUSE WAITED!

**Above:** Jim Steranko used many of the story-telling devices invented by Will Eisner, and added a few of his own. In this tier of frames from a *Marvel* horror story *At the Stroke of Midnight,* he duplicates a camera "pan" by splitting a single frame into four and depicting his characters at various stages of their climb up the stairs.

figure of Captain America in each of the four subframes. The effect is to drag out the instant of the Captain's turning away. Thus it adds importance to the action, suggesting perhaps Captain America's pleased realization that Rick will recover.

### The page

The comic page is generally read from left to right, down the page. It is possible to vary this for dramatic effect. (In China and Japan, comics are read from right to left, down the page, from the back of the book to the front.) It is important to arrange the panels in the correct order so that the reader may follow the story without confusion. If a potentially confusing layout arises through necessity, it is possible to direct the reader by bridging certain panels with arrows, although this method should be used only when all else fails.

The way the panels fit together to make a page depends on several factors, including the order in which the artist wants them read. The size and shape of the page and the action to be shown can all affect the number of panels and the way they fit together on the page.

Everybody has different ideas about how many panels you can fit on a page, but seven seems like a pretty good arbitrary average.

The natural instinct is to make sure the comic page is as tightly filled with drawing as it can be – if only to reassure editors that they are getting all the drawing they have paid for! Yet careful use of areas of "white space" can enhance the telling of a story. By manipulating the width of gutters between frames, the artist can achieve a number of effects, from scene changes to narrative timing to eye-pleasing page design.

There is no reason why an artist should not strive to achieve page designs which are easy on the eye. There are many ways of doing this. Artists such as Will Eisner, Jim Steranko and Frank Miller are all noted for their exceptional page designs. British artist Dave Gibbons has been creating some interesting symmetrical page designs in DC Comics' *Watchmen* series, although, to judge by the way the whole series is written, scriptwriter Alan Moore may also have had a hand in the designs.

The idea of two narrative threads running simultaneously has been used

**Above:** Will Eisner pioneered the idea of novelty frame borders. In this example from his 1940s *Spirit* strip, index card-shaped frames indicate that the story is told from police files. Note the scrap of paper "clipped" to the top right index card.

many times in comics. Neal Adams presented two scenes simultaneously during his stint on Marvel Comics' *The Avengers* by using the top half of the page for one scene and the bottom half for the other, over several pages. Will Eisner used the idea in his *The Spirit* strip of the late 1940s in his much-loved story, "Two Lives" (1948; reprinted in full in Eisner's *Comics and Sequential Art*, in Harvey's *Spirit* 1 and in Warren's *Spirit* 9).

And finally, scene changes can be handled in a variety of ways. As noted in the last chapter, I prefer scenes to be contained in multiples of whole pages: a scene can change halfway through a page just as easily, but when this happens it should preferably be between tiers.

The most basic type of scene-change device is a caption box on the first frame of the new scene: "Meanwhile, back at the ranch..." This is a primitive and clumsy way of going about it. If the artist is doing his job, it will be obvious to the reader that the scene has changed, and so that type of caption box becomes redundant.

Another technique, which relies on the reader recognizing a scene change without help, involves the trick of overlapping the end of a speech from one scene into the next. The first time I ever came across this was in Jim Steranko's classic first issue of *Nick Fury, Agent of SHIELD*, in the "it looks like it's starting to..." into "... rain!" scene change.

Alan Moore, the British writer of DC Comics' *Swamp Thing*, uses a similar idea

– so much so that it has almost become his trademark. How he does this is to have a character's speech or a narrative caption continue across a scene change, with the words superimposed over the new scene having some connection with the new scene. It is a difficult effect to describe, but the example reproduced here should give you the idea.

### Putting it on paper

Every artist takes a different approach to the task of breaking down a page. Some artists design the page straight onto the final artwork board, but this is time-consuming and wasteful of drawing material if you do not have the experience to get it right first time.

Joe Kubert, a veteran DC Comics artist who has drawn *Sgt. Rock*, *Hawkman* and *Tarzan*, designs his page layouts on typewriter paper. "I take a sheet of typewriter paper," he said in an interview, "and do breakdowns into what I feel will be an interesting panel layout, not forgetting I don't want to sacrifice legibility for design. Primarily, I feel our job is storytelling. If you confuse that by composing your page so that it's difficult to read, then regardless of how pretty the picture is, you've defeated your own purpose."

Another experienced comic-strip artist, Gil Kane, who has drawn *Starhawks* for newspapers and a host of characters in the comic books, also uses layout paper. He has said: "I generally work through the entire book with halfsize breakdowns and then go back to draw the panels. Nearly always, when I work with thumbnail sketches it removes certain inhibitions and I find I carry through my thumbnails 80 percent of the time. When I was working on my newspaper stuff, we worked out thumbnails every week for the entire week."

But the best advice you'll ever get is: do it the way that suits *you*.

**Below:** More page design magic by Frank Miller. He didn't invent this technique for portraying a burst of superheroic action, but he does it as well as anyone.

**Below:** A page from *Marvel* UK's *Doctor Who* comic strip as scripted by the author and drawn by John Ridgway. A single dramatic event is stretched to occupy most of the page.

**Left:** Top artist Neal Adams uses the Bat motif as an integral part of the page design in this example from DC's *Detective Comics.*

**Below:** A page from the comic strip adaptation of the film *Dracula Prince of Darkness* as it appeared in the British *House of Hammer* magazine. John Bolton's art allows the evil Count a more balletic grace than he displays in the movie.

**Below:** *Marvel* UK's *Captain Britain* strip both attacks and promotes patriotism in the same story. The imagery here tells of a Britain which is down but fighting back.

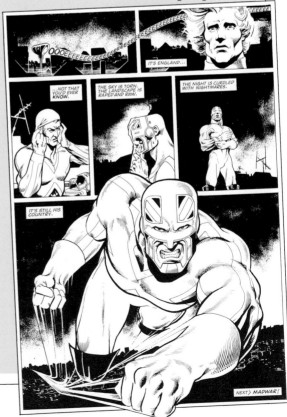

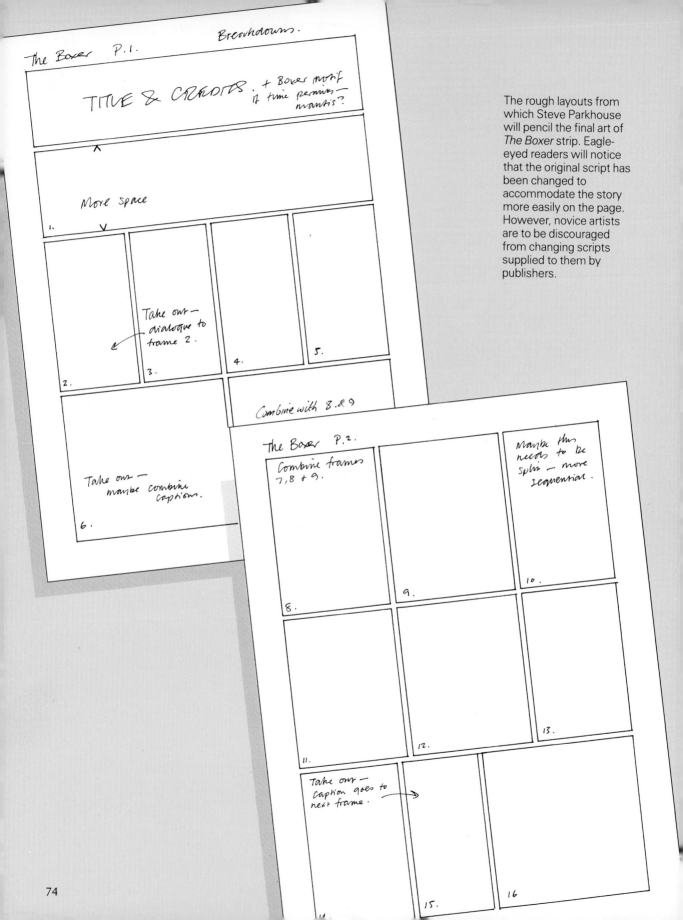

The Boxer P.1.                    Breakdowns.

TITLE & CREDITS. + Boxer motif
                    if time permits —
                              mantis?

More space

1.

Take our —
dialogue to
frame 2.

2.          3.          4.          5.

Combine with 8.& 9

Take our —
maybe combine
caption.

6.

The Boxer P.2.

Combine frames
7,8 & 9.                                    Maybe this
                                            needs to be
                                            split — more
                                            sequential.

8.          9.          10.

11.         12.         13.

Take our —
caption goes to
next frame.

15.         16.

The rough layouts from which Steve Parkhouse will pencil the final art of *The Boxer* strip. Eagle-eyed readers will notice that the original script has been changed to accommodate the story more easily on the page. However, novice artists are to be discouraged from changing scripts supplied to them by publishers.

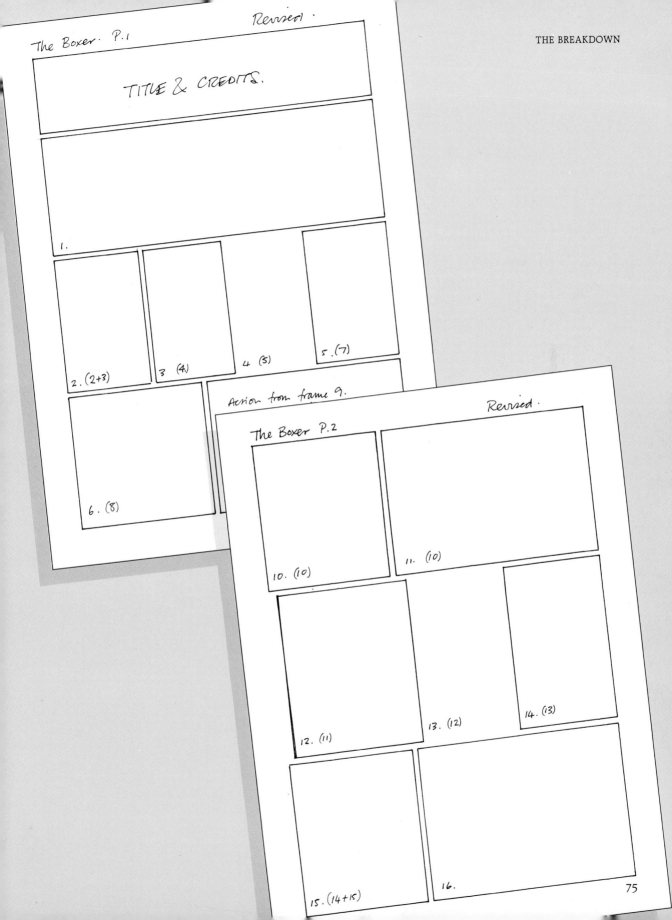

The Boxer. P.1

Revised.

TITLE & CREDITS.

1.

2. (2+3)

3 (4.)

4 (5)

5. (7)

6. (8)

Action from frame 9.

The Boxer P.2

Revised.

10. (10)

11. (10)

12. (11)

13. (12)

14. (13)

15. (14+15)

16.

# Penciling

**Above:** Whereas a blade is one way of keeping a point on your pencil, the same effect can also be achieved with fine sandpaper, or even coarse paper.

Once you have broken down your script into the correct number of frames you can set about penciling.

The first responsibility pencil artists have is to make sure they are drawing their artwork to the correct size. This might seem obvious, but you would be surprised how many professional artists turn in work that has been drawn to the wrong proportions. If artwork is drawn to the wrong proportions, it will not sit comfortably on the printed page: it will have too much space top and bottom, or at the sides. Most comic-strip artwork is drawn "half-up," 50 percent larger than it will appear in print. (The terminology is somewhat confusing, because the 50 percent referred to applies to the lengths of the sides of the board or paper. In fact, half-up artwork has about twice the *area* of the printed result.) In the old days, art was drawn "twice-up" (twice the printed size), but most publishers of strip material prefer half-up these days. If you are submitting samples to a publisher, simply measure the material that the publisher is already producing and multiply the dimensions by 1.5.

Penciling is the part of the process in which most of the real drawing is done. How much or how little of the pencil drawing you complete depends on whether or not you plan to ink the pencil marks yourself. These days it is commonplace for the artwork to be prepared using a division of labor between two or more artists. In some instances, a strip might be laid out by one artist, penciled by a

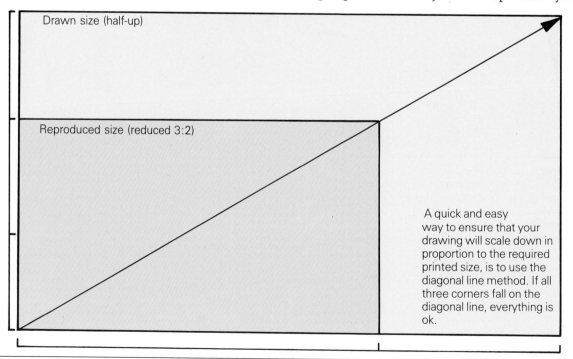

Drawn size (half-up)

Reproduced size (reduced 3:2)

A quick and easy way to ensure that your drawing will scale down in proportion to the required printed size, is to use the diagonal line method. If all three corners fall on the diagonal line, everything is ok.

Essential tools for
cleaning up the surface of
drawing boards: a can of
lighter fluid; French chalk;
and absorbent paper
towels.

**Preparing the board**
The surface of the board
can be cleaned with an
eraser to remove any
greasy spots which might
repel the ink.

Use a pencil that is neither
too hard nor too soft, and
try not to erase too often
as this ruins the surface of
the board.

It is always wise to make
a protective covering for
your artwork by attaching
a piece of layout paper to
the reverse of the board
and folding it over to cover
the art.

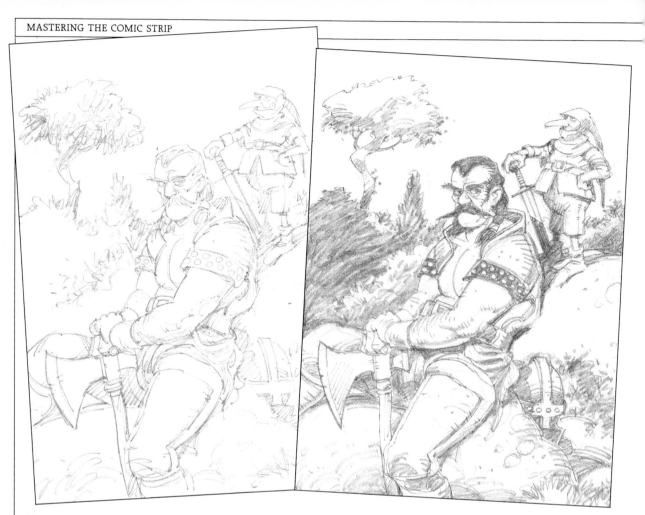

**Above:** The degree of detail in a pencil drawing depends on whether the artist does his own inking. In this picture, the artist has left out many of the finer details. He will add these in the inking.

**Above right:** However, if the pencil artist knows that someone else will be inking his work, he will include all the detail to be contained in the final drawing in an effort to keep the finished product as close to the original scheme as possible.

second and inked by a third, with a fourth collaborator – the letterer – adding the scripter's words. Further, more than one artist might be involved at each of these stages.

If the penciler and the inker are to be the same person, the pencil-work can be little more than an indication, or rough sketch, for the inks. However, if the work is to be inked by a separate artist, the pencil-work will need to be "tight" – that is, it will need to be a finished drawing, perfectly legible, with nothing needing adding: it has to be drawn so that the inking artist can see exactly where he or she has to put their lines. So, no turning your pencil on its side and blocking in areas of gray in varying tones! (In fact, well known artist Gene Colan *does* pencil like this, but his work looks good only when he gets the right inker – and, of course, Colan has been in the business for years and gets away with habits that would not be tolerated in a newcomer.) Apart from anything else, editors like to be able to look at a page of penciled art and have a good idea what the finished inks are going to look like. It never hurts to spell things out for everyone down the chain, from editors to inkers to letterers.

The penciler is *the* key person in the art team. Only those pencil artists with the most dynamic and original drawing styles stay around long enough to become famous. Jack Kirby, co-creator of such comic megastars as *Captain America* and *The Fantastic Four*, comes at the top of the list. Top men like *Superman*'s Curt Swan and John Buscema, who has drawn *Conan the Barbarian* for the last 14 years, come a respectable second. Because these top names turn in pencil art which is immediately legible to editors and inkers, their own art

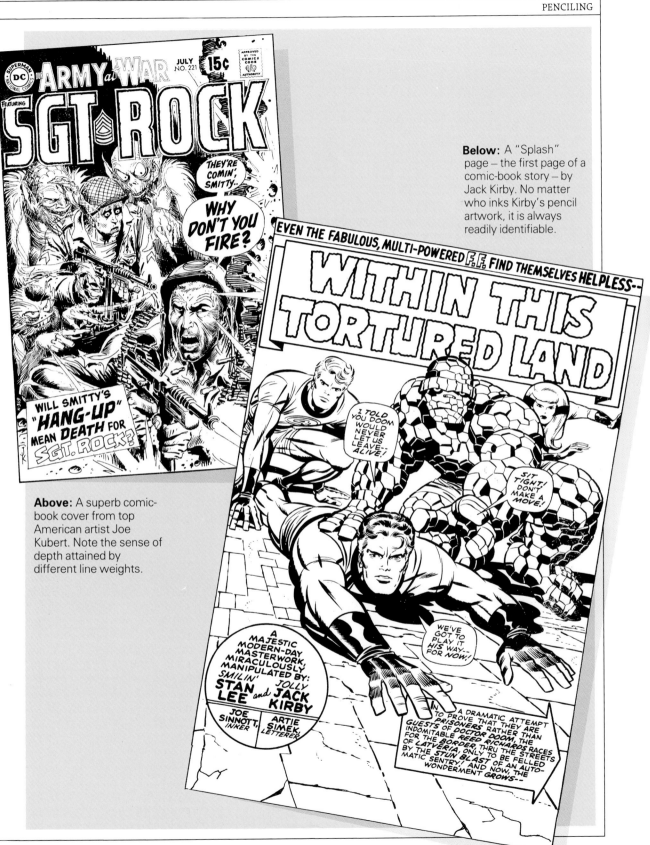

**Above:** A superb comic-book cover from top American artist Joe Kubert. Note the sense of depth attained by different line weights.

**Below:** A "Splash" page – the first page of a comic-book story – by Jack Kirby. No matter who inks Kirby's pencil artwork, it is always readily identifiable.

techniques shine through. There is no way an inker, no matter how strong a style he or she has, can overwhelm the highly stylized pencil art of, say, Jack Kirby.

Tempting as it might be to a beginner to raid the technique of one of the "greats" in the hope that some of the greatness might rub off, it is not an advisable practice. It is a bit like cheating at solitaire: you'll probably get away with it, but in the end who are you fooling? Far better to try to develop an original style all your own.

Sometimes it is even possible that an artist's idiosyncratic style can compensate for his or her shortcomings as a draftsman. Nevertheless, a reader is always more drawn into a story when the artwork isn't full of glaring inaccuracies. In order that they always have references to hand, many artists keep picture "morgues," files of pictures from newspapers and magazines of everyday objects and locations. It is simply not possible for an individual to memorize the exact shape of every conceivable object he or she might have to draw, so most comics artists build comprehensive files, containing all sorts of photographs and artwork, which they maintain in some sort of logical order so that they can find the necessary references with the minimum of timewasting. If called upon to draw a New York city street, an artist living in Edinburgh can save the cost of a plane ticket – or even of a trip to the library – by having his or her own clippings file. Whether or not you think it is cheating to use photographs is a matter only you can decide, but you should bear in mind that time is money, and that anything that saves time has obvious advantages.

### What to draw

What you draw is sometimes less important than what you leave out. The fact is that comic-strip art is a kind of visual shorthand. The best kind of comic-strip artwork is not a photographic representation of reality but a kind of schematic, or diagram. During the 1970s there was a vogue among many of the younger artists whereby they cluttered up their artwork with as much extraneous detail as they could muster: they seemed to think that, the more detail on a drawing, the closer to reality it is. This is a mistake made by many young and inexperienced artists. Perhaps they want to make a good impression on their editor by showing how much work they have put into a job!

In fact, the average person has a great deal of trouble absorbing visual detail, as any policemen who has tried to get descriptions of criminals from eye-witnesses will tell you. Most people will, at best, note that a drawing has a lot of detail, but will stop short of analyzing and absorbing the detail. Moreover, too much visual detail, just as when a comic strip is overloaded with words, slows the reading-pace right down so that the story drags.

Joe Kubert is well known for producing excellent artwork that tells the readers everything they need to know to enjoy the story – no more, no less. "When I draw *Tarzan*," he said in an interview a few years ago, "I want to generate the same kind of excitement in my readers as the strip did in me when I was a kid. I tried to analyze the elements in the old *Tarzan* strips by Hal Foster to find out what it was that had this effect on me. I decided it was a matter of simplification and directness. By eliminating all extraneous artwork and riveting into what was the most dramatic part of that particular panel, I got what I felt would actually hold the reader from panel to panel. In addition, I tried to get the drawing construction as fundamentally sound as possible, so that the characters would appear absolutely real. The composition of the page is of lesser importance to me than the planning of dramatics and continuity."

One way an artist can focus the reader even more firmly on the characters – perhaps to make an emotional impact or some other important point – is to ensure there is no background detail that distracts the attention. Thus it is perfectly acceptable for an artist to leave out background details from an occasional frame and merely draw the characters against a white background –

**Left:** John Buscema's powerful penciling style is still readily identifiable, no matter who inks over his work. This example is from Marvel's *Conan the Barbarian* and is inked by Ernie Chan.

**Above:** Humorist Posy Simmonds, like most newspaper strip artists, inks her own work and thus the finished work accurately reflects her true drawing style.

**Above:** Carl Barks' Disney strip work was always written, penciled and inked by Barks himself. This is a previously unpublished page of artwork for Donald Duck.

**Right:** Neal Adams' penciling work is also instantly recognizable under the smooth inking style of Dick Giordano. In this *Green Lantern* page for DC Comics, Adams' skill in depicting facial expressions is shown to good effect.

*provided* the background details have been established in an earlier panel. The readers are left to fill in the necessary backdrop using their own imagination, with the establishing frame as a reference.

But whether the background is drawn or not is of little importance compared to how the artist draws the important story elements: the characters, their facial expressions, their body postures, and the props they use. How these are presented to the reader must be as convincing as possible *within the context of the story*. For example, in an adventure strip the story elements should be drawn in a naturalistic way, in which case some *acting* ability on the part of the artist is required. An artist must be able to distinguish between "mild surprise" and "shock-horror," and successfully convey that difference to the audience. On the other hand, in the context of a humor strip, exaggeration is quite permissible, and probably desirable: considerable comedic effect can be gained from having characters over- or under-react. Yet this requires no less sensitivity on the part of the artist than the naturalistic adventure strip. A humor artist needs to know exactly how to convey a natural reaction before he or she can exaggerate or underplay it. In other words, the best humor artists must already have mastered the naturalistic techniques of storytelling, so that their distortions of reality for humorous effect are believable.

### The characters

When it comes to designing characters, the most valuable tools comic artists have are their powers of observation. As with writers, artists can find the best and most interesting fictional characters in the world around them: relatives, neighbors and even pets can form bases for engaging characters. If the artist is working from a script by a separate writer, he or she should find some clues there. I think the best help I can give an artist when I am writing a script is to describe my characters in terms of known personalities. Thus it is helpful to pigeonhole a character by referring to her as a "Marilyn Monroe type" or a "Ruth Gordon type," provided both writer and artist add something extra to these descriptions; anything less is just theft. Yet no script can ever convey a complete picture of the characters to the artist, and this is where the artist's imagination comes into play – because characters are so much more than mere physical

**Below:** A selection of classic comic character archetypes. You may think you recognize them, although they have appeared under many different names throughout the history of comics.

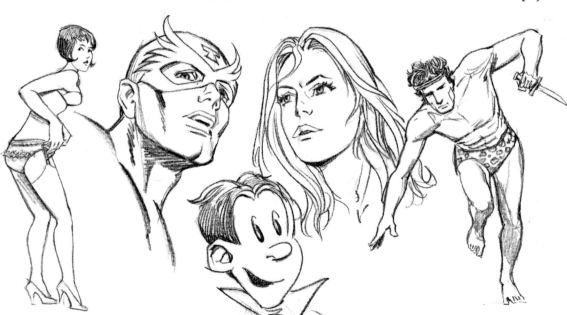

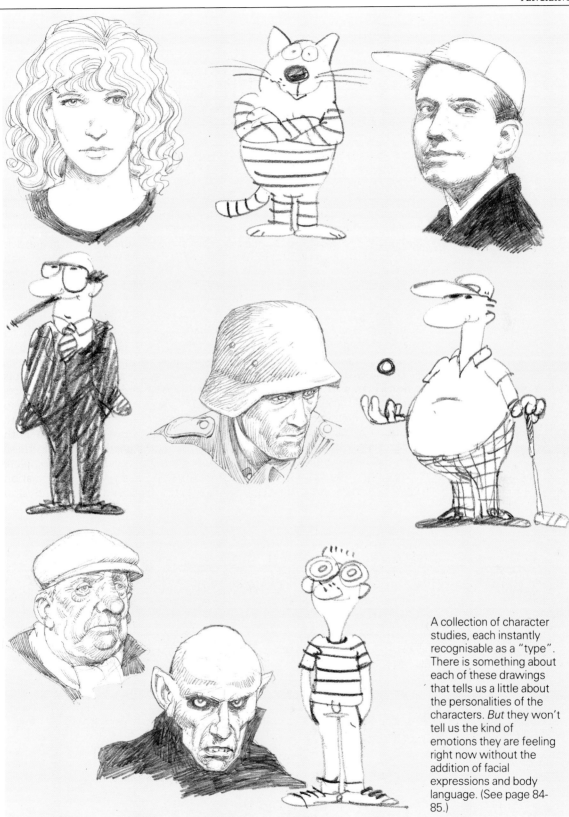

A collection of character studies, each instantly recognisable as a "type". There is something about each of these drawings that tells us a little about the personalities of the characters. *But* they won't tell us the kind of emotions they are feeling right now without the addition of facial expressions and body language. (See page 84-85.)

Here are the same five characters that appeared on page 83 seen in full-figure shots. From each drawing we can glean much more information about the current state of mind of the characters than the head shots could ever tell us.

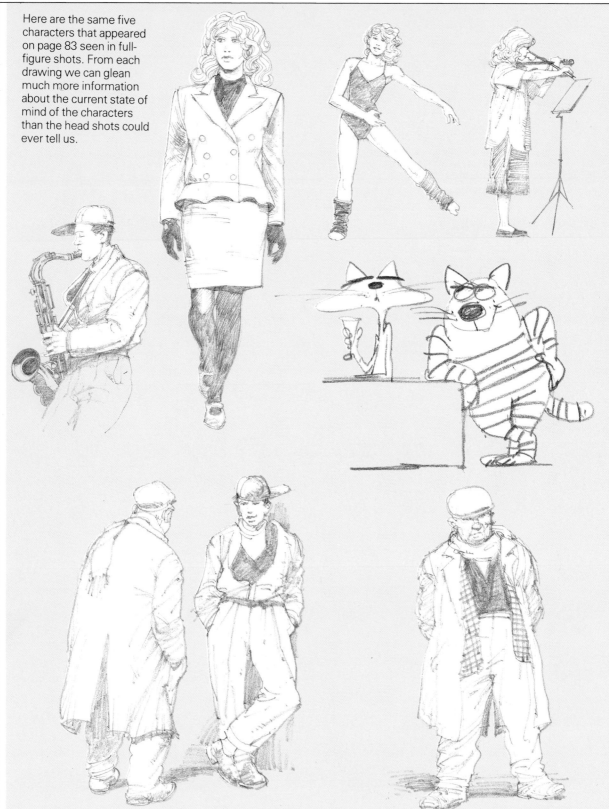

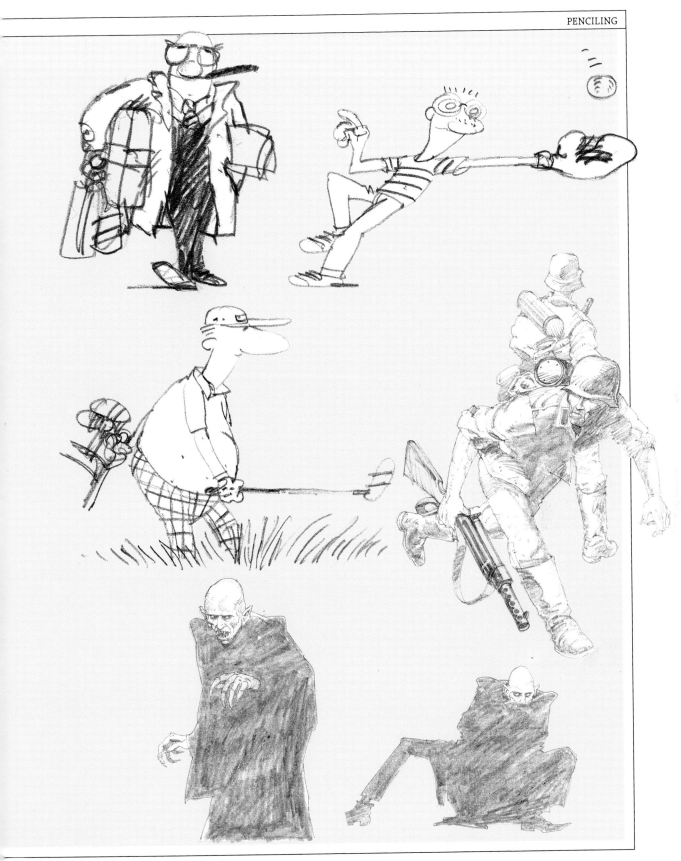

A collection of facial expressions and examples of body language. Each clearly conveys a different message to the viewer. The skill and subtlety with which a talented artist can use body language and facial expression will add power to a well constructed story and, in many cases, rescue a badly constructed one.

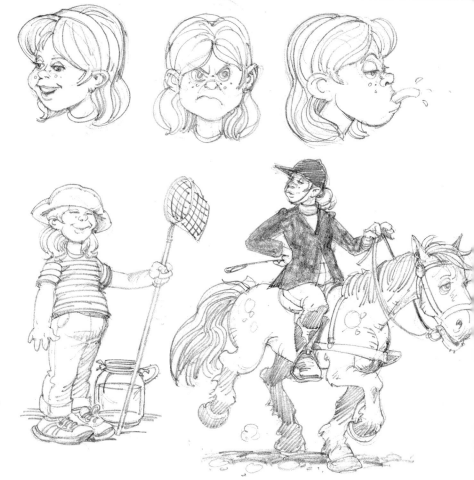

attributes. A character is more clearly identified by his or her personality traits. How do we judge a person's personality? By what they say and do. Fortunately for the artist, what a character says is provided by the scriptwriter. Yet the artist can put flesh on the verbal bones by making sure the characters' actions complement their words – or, in some cases, contradict their words.

### Developing characters

The concept of presenting readers with characters who appear to be "real people" is one of the most challenging aspects of creating comic strips. In real life, it is almost impossible to get to know every facet of another person's character, regardless of how intimately you may know them. It is even harder for a writer to give readers a genuine insight into characters in a novel, despite there being virtually unlimited space. Think, then, how much harder the same task is for the comic-strip creator.

However, the fact is that comics are a medium of Action rather than Words. And it has been said that you can get a better understanding of a character's personality by paying attention to their actions rather than to their words.

But comics have limited space and even the most sophisticated comics have to content themselves with two-dimensional characters. Indeed, some of the most successful comics characters can be summed up with two fundamental characteristics each. For example:

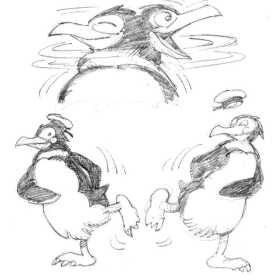

Spider-Man – An arachnid-powered youth with an ailing aunt.

Batman – Athletic detective who fights an obsessive war on crime.

Captain Marvel – A small boy who, with a magic word, turns into a costumed hero.

The rule to remember when trying to create believable personalities is that *characters display characteristics* – by characteristics I mean bad temper, jealousy, dishonesty, sense of humor, etc. It is possible – even common – to have two characteristics in one person that seem to contradict each other. For example, a character can display a sense of humor and no sense of humor at all at different times, or over different matters.

To determine the various characteristics that make up a personality, try to analyze the personality of someone you know well or, even better, yourself. At first, you can even base the characters you invent on people you already know. Finally, avoid the temptation to make every character you create an idealized version of yourself. This is self-indulgent, boring for the reader and won't make people you know like you better...

## Facial expressions and body language

The faces that characters pull and the postures their bodies assume are absolutely vital in conveying what they are thinking. In real life, the average person tells everyone what they are thinking whenever they move the muscles of their face. Some people can show facial expressions and postures which have

nothing whatever to do with what they are thinking. Usually, such people are called liars – although the smart ones go legitimate and become actors!

The problem for the comic-strip artist is that the human face is the most familiar object of all. We look at human faces more than we look at anything else. We know intuitively the meaning of every expression a face can make. And, just as you cannot be fooled by real-life facial expressions that are not quite right, nor can the readers of any comic you might draw. Similarly, we all recognize the arm-gestures used to communicate such emotions as grief and mirth. So it is absolutely vital that a comics artist can create the correct expressions called for by the script. Sometimes in comics a character's speech can be ambiguous, as dialogue is of necessity rather clipped, and this is where an artist's grasp of body language becomes an invaluable part of the storytelling process. In extreme cases, a comic-strip story can be told relying entirely on body language, without resorting to dialogue of any kind.

There are lots of ways an artist can learn about body language. One way is to sit in front of a mirror and pull faces. The only drawback here is that people who are inexperienced in the craft of acting tend to go over the top. This can result in exaggerated expressions, or "mugging" – fine if you are drawing gag strips, but characters overacting in straight adventure stories can be irritating, not just for the readers but also for the scriptwriter, who ends up having ham actors rather than characters in his or her story.

Perhaps a better method for the novice is to watch television with a sketch pad and a pencil handy. It is even better if you have access to a video recorder with a

An artist may be called upon to draw a bewildering array of props, such as weapons and vehicles. Where possible, try to give "weight" to the inanimate objects you draw. For example, the depiction of smoke or tyre marks will make the props more lifelike.

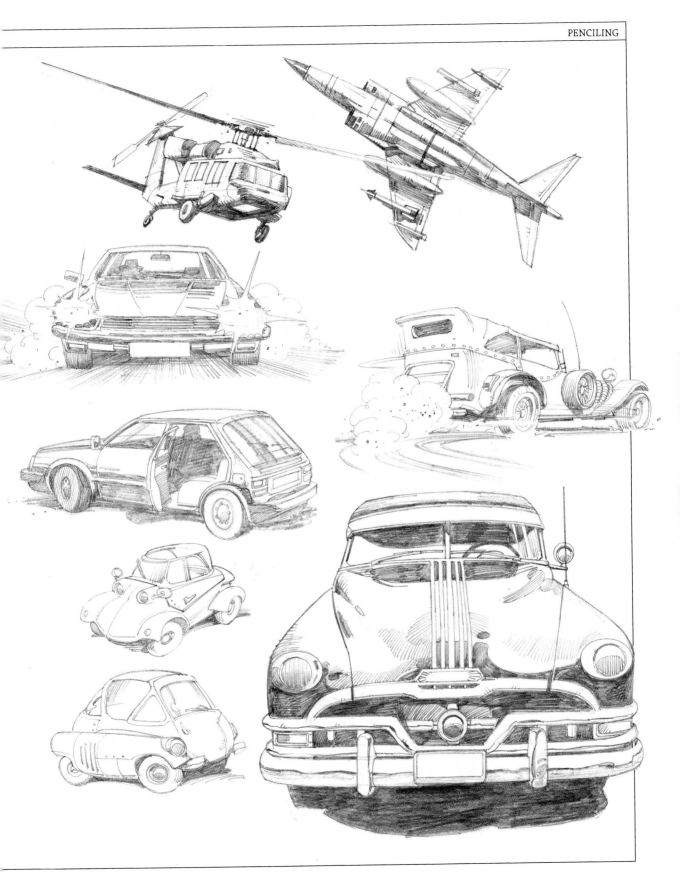

"freeze frame" facility. You can sit down with some of the greatest actors in the world to study, frame by frame, and sketch some of the postures they have adopted and the faces they have pulled. Alternatively, you may find photographs from magazines and newspapers of some use, but your scope will probably be limited by the narrow range of expressions found there.

The best reference work on the subject of body language and facial expressions is Desmond Morris's *Manwatching*. Although you may find the text a little difficult, the pictures are an absolute treasure-trove of human non-verbal communication.

## Props

The word "prop" is an old theatrical expression, used also in films and television, which is short for "properties": it means any inanimate object which might be required by the characters in a story in order to advance the plot. For our purposes, it means any object other than a character.

The way an artist draws the inanimate objects in a comic strip goes a long way toward establishing in readers' minds exactly what the function of each object is. For example, an automobile can be drawn in several different ways. If drawn from a low angle, rushing toward the reader, with headlamps blazing, it can be made to seem very sinister and menacing. But if the same car is drawn standing still, facing away from the reader, with one of its rear doors open, it appears to offer an escape from danger.

In brief, great consideration should be given to what the story demands the *function* of a prop to be, after which the artist should do his or her best to convey that function in the way they draw the prop.

## Composition

The way in which a character or object is framed within the panel is of vital importance to a reader's perception of the story. This is not a question of close-ups and long-shots – we dealt with those in the last chapter – but of where in the frame each of the elements of the scene is positioned. In frames where there is only one element required, it is normal practice to place that element at the center of the panel. However, panels containing only one element lack drama and should be used only when the artist is trying to focus the reader on that element for a *reason*.

Things start to get a little more complicated when the artist is called upon to frame more than one element in a panel. In this respect, the panel becomes an individual picture, with drama and dynamics all of its own. The traditional concepts of picture composition apply just as much to a comic panel as to an oil painting, an individual shot in a movie or TV show, or a photograph.

Many books have been written on composition, but none of them are of much use to the aspiring comic-strip artist except in the most general terms. This is because, in comics, a panel should not be composed to be a separate and complete unit of art, like an oil painting: rather, it should lead the reader's eye on to the *next* panel. How this can be achieved is best conveyed by example rather than description: the examples shown here speak more eloquently than could any written words.

## A practical note

The best artists try to make sure that the pencil artwork they hand in for inking is clean and free from smudges, fingerprints, coffee stains, and so on. One of the best ways to end up with clean pencil art – short of wearing surgical gloves – is to start at the top left of the page (assuming you are right-handed) and draw from left to right, down the page. It can help to place a small square of paper – say 6in × 6in – beneath the heel of your drawing hand.

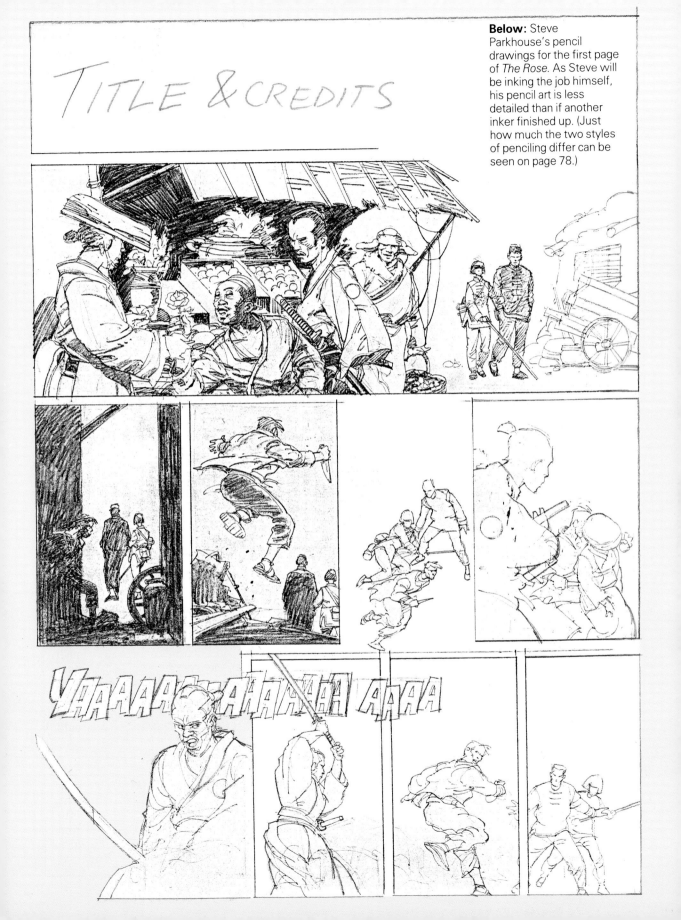

TITLE & CREDITS

**Below:** Steve Parkhouse's pencil drawings for the first page of *The Rose*. As Steve will be inking the job himself, his pencil art is less detailed than if another inker finished up. (Just how much the two styles of penciling differ can be seen on page 78.)

YAAAAAAAAAAAAAA AAAA

# Inking

Inking refers to the act of going over the pencil lines on the page in black India ink, a vital step if the artwork is to reproduce properly when placed under the printer's camera. With a pencil, an artist can render images in shades of gray, but with the cheap printing processes normally used for comics these grays do not register under the printer's camera. So, in inking, an artist must break down the grays into blacks, whites or mixtures of the two, the latter achieved by "feathering" (using close-set parallel lines of black ink) or "cross-hatching" (criss-cross lines of black ink). In this way, artists can add textures to their work, determine the lighting styles, and control the overall dramatic effect of the comic story.

But, even if they are "merely" inking someone else's pencil art, inkers must be accomplished artists in their own right. A talented inker can bring quality to a mediocre pencil job, just as a poor inker can destroy the artwork of a top-class pencil artist.

The best artists, of course, are able to wield pencils and inks with equal ease. There are a few artists who have earned reputations for being equally adept at either inking others' pencil art or providing pencil art for a separate inker; Sal Buscema and Joe Staton are two such artists. For the most part, comic-book artists specialize in one or the other – although there are a few who habitually ink their own pencils, like pioneer *Spider-Man* artist Steve Ditko, and in British and European comic books the trend is for artists to pencil and ink their own work. In newspaper strips, however, it varies from artist to artist as to whether they employ assistants or not. Certainly, novices in the newspaper-strip business have to both pencil and ink their artwork. Thus it pays to be able to handle both pencil and inks to a professional standard, no matter where in the comics business you intend to earn your living.

**Below:** It is generally agreed that the best artwork results from the artist inking his own work, a practice more common in British comics than in American. Here, the exceptionally fine work of Steve Ditko on *Marvel's Spider-Man.*

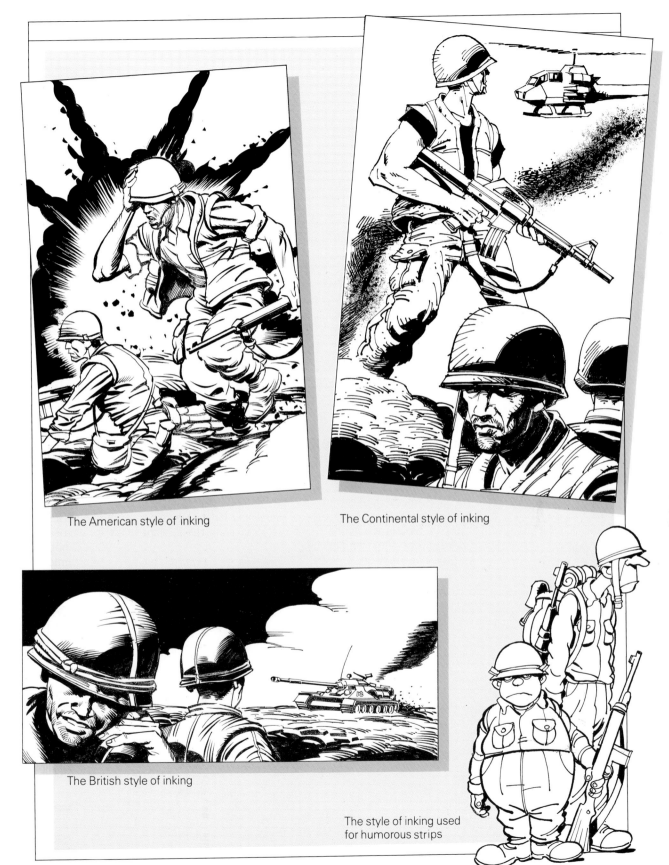

The American style of inking

The Continental style of inking

The British style of inking

The style of inking used
for humorous strips

### The tools of the trade

There is no "correct" way to ink over pencil art. Every artist has a separate technique. The commonest method is to use a sable brush, usually something between a 0 and a 3. Winsor & Newton seems to be the most popular brand of brush, much to the surprise of some professional artists. Harvey Kurtzman, the creator of *Mad*'s and *Playboy*'s *Little Annie Fanny*, once said, "I'm constantly amazed and perplexed at the dominance of Winsor & Newton sable brushes. Something has got to be done! How long is this monopoly going to go on? But they're the only ones that work."

The fact is that inking with a brush has become popular because a brush holds more ink (which means you dip less often) than the types of mapping pens used for inking artwork. Also, a brush gives a more varied line.

Some artists ink with fiber-tipped pens. Neal Adams, the top comic-book artist of the 1970s and now also a successful advertising artist, uses a Pentel for preference. "I came round to using a Pentel after a lot of experimentation," said Adams in an interview. "I found it helps me in storytelling. It briefens the technical difficulties. The idea of having to keep the pen clean, the brush pointed, or getting angry when my brush is splitting hairs and other problems that keep holding me back don't happen with a Pentel."

The big problem you get with Pentels and other similar pens is that, if you make a mistake, you cannot cover it up with process white, because the ink from such pens bleeds through. You can use patch paper, but this is ugly and you can see where the line passes from the board to the patch, even after the artwork is printed. The simplest answer, if you insist on using markers for inking, is not to make mistakes!

Other artists who use markers for inking include Alex Toth and Gil Kane, probably two of the best artists in the business. Both have worked in both newspapers and comic books. Gil Kane points out that there are limitations inherent in the use of markers for inking: "Because I've been a pencil artist most

**Brush care** Keeping the ferrule of the brush clean is vital. Simply wipe it with absorbent paper towels.

Excess ink can be wiped away. You should wipe off ink before washing.

The best way to wash a sable brush is with soap and water. Work the lather well into the bristles to get the ink out of the ferrule.

0

1

2

**Above:** Different-sized brushes produce different weights of line.

The tool used to put the ink onto the drawing will determine the final look. **Right:** This parrot was inked with a dip pen and Indian ink. The result reveals lots of fine lines. **Below left:** The felt-tip pen gives a bolder, sturdier line, but cannot give the fine-line detail of the dip pen. **Below right:** The brush gives the smoothest ink line of all. Of course there is nothing wrong with using all three in the same drawing.

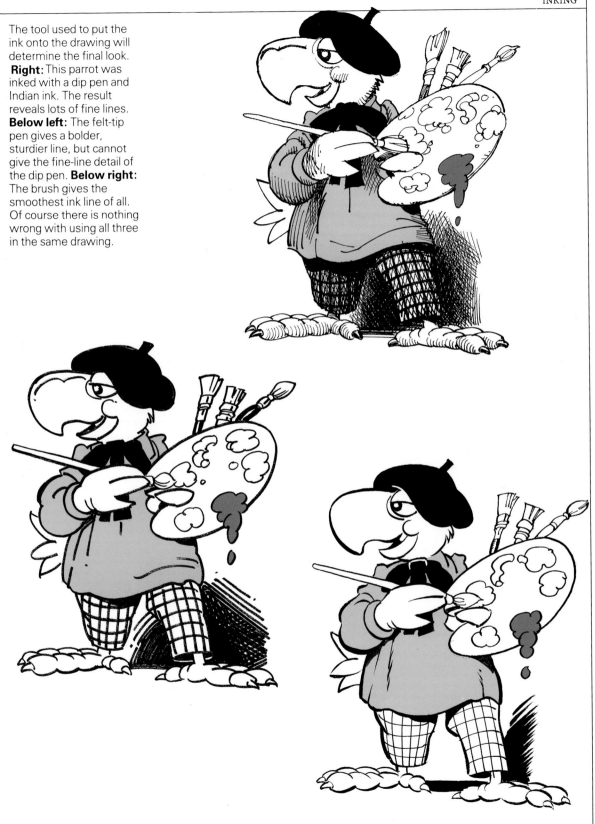

of my life, I never developed the precision and delicacy that most people evolve when they're using a pen or a brush. Using a marker, I can get a range of effects and I find them very satisfying. But I wish it were possible for me to use a pen or brush more effectively, because I find certain limitations with a marker. I take advantage of my limitations and further my technique as far as I can. I find I am able to work quickly. I'm never going to be the kind of artist that does long and highly evolved drawings. It's simply not what I'm concerned with. I'd like to have a piece of work as finished as possible, but I like to deal with dramatic ideas."

It is probably best to resist the temptation to ink with stylo-type pens (Rotring is probably the best known brand in this line). Although such pens run on India ink from a self-contained cartridge, which means they do not have to be dipped in ink like brushes, the nature of their nibs means that the lines they draw are of constant width, a decided advantage when they are used for what they were designed for – mapping and drafting – but the last thing a comic-strip artist wants, except perhaps for ruling panel-borders and drawing speech balloons. Lines of constant width are *boring*. They tire the eye and make everything you draw look like a cardboard cutout rather than a solid, three-dimensional object.

If, however, you prefer to ink with a brush and you have to draw straight lines within the panel, as part of the artwork, you should learn to draw straight lines, with your brush, using a ruler. The technique involves tucking the fingers of your

**Erasing** Process white dries in the jar but can be revived with a little water.

Apply process white with a sable brush to clean and tidy up artwork.

On some boards stray ink lines can be scratched away with an X-acto knife.

**Straight lines** The simplest way of getting a straight line is with a pen and ruler. These tools are used mainly for ruling panel borders.

It is also possible to rule lines with a sable brush and ruler. This gives a more interesting line but does require practice.

A useful tip for frame borders is to rule the lines slightly longer than they need to be then remove the excess with process white. This ensures a sharp corner on the border.

left hand (assuming you are right-handed) under the drawing-edge of your ruler, so that the ruler makes an angle of about 45 degrees with the paper. Then, holding the brush between your thumb and forefinger, and using the first knuckle-joint of your third finger as a support against the top surface of the ruler, you can draw the ferrule of the brush along the raised straight-edge of the ruler. You can vary the thickness of the line you make by increasing or decreasing the pressure of the brush on the paper. It is a tricky technique to master, but straight lines drawn with a brush look far less mechanical than those put down with a pen, and they blend into your artwork better.

For ruling panel-borders it is probably best to use a pen. Here, a stylograph pen is ideal. However, there is a danger when ruling straight lines with a stylograph pen: ink may "bleed" because of capillary action between the ruler and the board. In other words, ink can be sucked into the microscopic space between the ruler and the board due to what is called surface tension. The best way to avoid this is to increase the gap between the ruler and the board. Many rulers are manufactured with a beveled edge, so that you can simply use them upside-down to prevent ink bleed. Steel rulers, on the other hand, have both sides flat. However, you can put a couple of layers of masking tape on one side of a steel ruler and use it taped-side down, so that there is enough of a gap between ruler and board to prevent bleeding.

### Feathering and cross-hatching

When you are using India ink on white board, you must remember that you cannot water your ink to produce shades of gray (unless you come to a special arrangement with your publisher!). After all, the printer cannot water *his* ink. Thus you must compromise and achieve your shades of gray artificially. This can be done by feathering, the use of closely spaced parallel lines to achieve an effect of grayness. Harvey Kurtzman defines feathering as "shorthand for a changing tone." He explains: "Instead of making an actual gradation of tone, you paint in pure black, a series of parallel pointed strokes that suggest gradation. But that isn't the way things are in nature."

There are countless methods of feathering. You can use straight lines, curved lines, long lines, short lines... in fact, whatever it takes to achieve the effect you want. An interesting variation on the regular method of putting down black parallel lines on white board is to put down an area of solid black ink, let it dry, and then feather on top of it with process white.

An alternative is cross-hatching. This technique involves feathering first in one direction and then feathering again on top of that, usually at an angle of 90

Hatching. Ink is laid down with a dip pen in radiating lines. This could denote a blast of light.

Pebbling. Ink applied with a dip pen in tiny circles of varying size.

Feathering. Ink is painted in with a sable brush. This is a method favoured by many artists for showing folds in cloth.

Cross-Hatching. Usually done with a dip pen, this technique can be used to show shading on a curved surface.

Curved-Hatching. Achieved with a dip pen, this technique isn't seen very often in contemporary comics.

Brush ruling. Ink put down using a brush and a rule for a straight-line effect.

Dry Brush. Ink laid down with a brush wiped almost dry. It is not seen very often in comic art.

Scratching. Ink is painted onto board, allowed to dry, then scratched away with a scalpel-point. It works best on board.

degrees. Cross-hatching was at its most popular during the Golden Age of comic-strip art, the 1930s and 1940s, and is not seen much these days, except in the work of certain classically inspired comic artists, such as Berni Wrightson.

Taking cross-hatching one step further, the classic partnership of Jack Kirby and Joe Simon, who created such comic legends as *Captain America* and *The Newsboy Legion*, created another kind of comic-book shading. Explains Joe Simon: "It wasn't up-front square cross-hatching. The cross-hatching we did was angular – you'd wind up with lots of little triangles if you looked at the art under a microscope. The lines would be heavier in the dark areas, lighter in the paler areas. Our cross-hatching wasn't flat. We'd try to achieve varied tones."

Another technique is stippling, which during the 1930s was a popular way of getting grays. It consists of achieving gradation through making areas of black dots, using a brush or a pen. Some artists used to stipple grays around the speech balloons at the tops of their panels. Stippling became popular again during the 1970s with the rise to prominence of the artwork of the British comic-strip artist Frank Bellamy, responsible for the *Daily Mirror*'s comic strip *Garth. American Flagg!* artist Howard Chaykin is currently using the stippling technique to good

**Above:** This study is drawn entirely in pen and ink using a cross-hatching style. The result gives a look similiar to 19th–century engravings.

**Above:** This drawing of Merlin uses nearly the complete range of inking techniques – hatching, dry brush, feathering, cross-hatching and pebbling.

effect, on both *American Flagg!* and his new strip *Time.*[2]

With the poor printing processes generally used for comic strips, in both comic books and newspapers, there is a tendency for black lines which are too close together to merge. So, if your feathering is too "fine" – that is, if the lines are too close to each other – you may well find that the printed result is an unsightly black splodge. Remember, too, that you are drawing for reduction, so fine feathering that looks terrific on the original artwork may look a mess when printed – or even disappear entirely.

## Textures

The most difficult part of inking comic-strip art is achieving the correct textures on the various surfaces on which you are asked to draw. Obviously, the audience must be able to distinguish between fur and feathers, wood and water, and so on. And the only clues the audience has are those provided by the inker.

Explaining how to achieve these differences is difficult in words. By far the best way for you to learn about textures is to examine the work of professional comic-strip artists. To help you along, we have reproduced a selection of textures as inked by some of the top artists in the business.

**Below:** Generally regarded as one of the best artists to emerge from American comic books during the 1970s, Berni Wrightson is noted for his fine-line inking techniques. Perhaps the high point of his Seventies work was *DC Comics' Swamp Thing.*

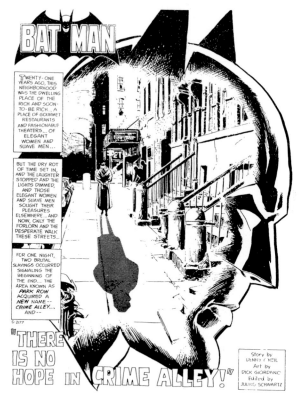

**Above:** Currently Editor-In-Chief of DC Comics (and known as an inker), Dick Giordano has turned in many fine complete art jobs. His own favorite is the Batman story, *There is no Hope in Crime Alley.*

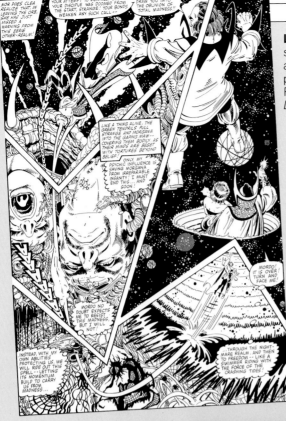

**Left:** The superb inking style of Terry Austin adds a touch of quality to the pencils of Marshall Rogers on *Marvel Comics' Dr. Strange* strip.

**Below:** A superb example of the cross-hatching inking style of Syd Jordan on his syndicated newspaper strip, *Jeff Hawke*.

**Left:** A fine example of a wash and ink rendering style by British artist John Bolton on an adaptation of an old Chris Lee Dracula movie from the UK horror magazine of the 1970s, *Halls of Horror*.

**Opposite:**
The pencil art complete, Steve Parkhouse begins to ink the artwork for *The Boxer* story, "*The Rose*". Note how the details are tightened up and the lighting effects more clearly defined.

**Right:** Dick Giordano, generally accepted as one of the best inkers in the business, shows his expertise over penciled artwork by Neal Adams in a page from the award-winning DC Comics series *Green Lantern*.

## A vital point

Something you should bear in mind, whether you are inking your own pencils or someone else's: try to imagine that the pencil lines are not there, and that you are drawing directly onto the board. If you merely *trace* the existing pencil lines with your brush, the results will look flat and uninspired. You have to *draw* while inking. The idea is that you are creating the lines all over again, giving them life and vibrancy with the sheer force of your drawing-power. Anything less is just a mechanical skill and reduces any artist, no matter how talented, to an artisan.

Top inker Dick Giordano says of inking other artists' pencil work: "To a degree, any kind of drawing is a technical exercise. But I think inking is probably more of a personal expression than penciling is. A penciler is bound by more regulations than an inker is. A penciler is bound by the regulations governing perspective, anatomy and so forth. An inker isn't really bound by these. Those things have already been established by the time the work comes to the inker. So I can express myself more while inking and I think that's why I like inking some artists better than others. They allow me more leeway in being Dick Giordano, which is important. Ego is part of what we're doing. Without ego it's very hard to sit down all day with a brush in your hand. It's just as boring as making widgets in a factory. And in some ways more painful. Until I figured out how to put tape on the ferrule of my brush, I had calluses on my fingers…"

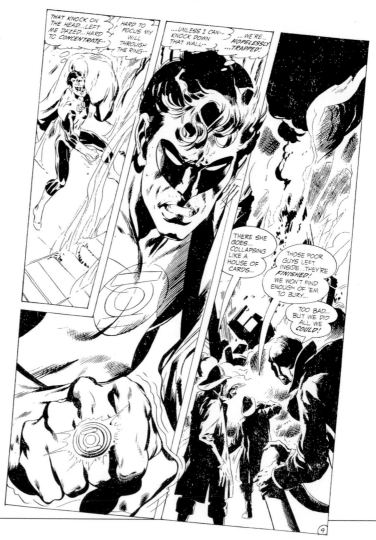

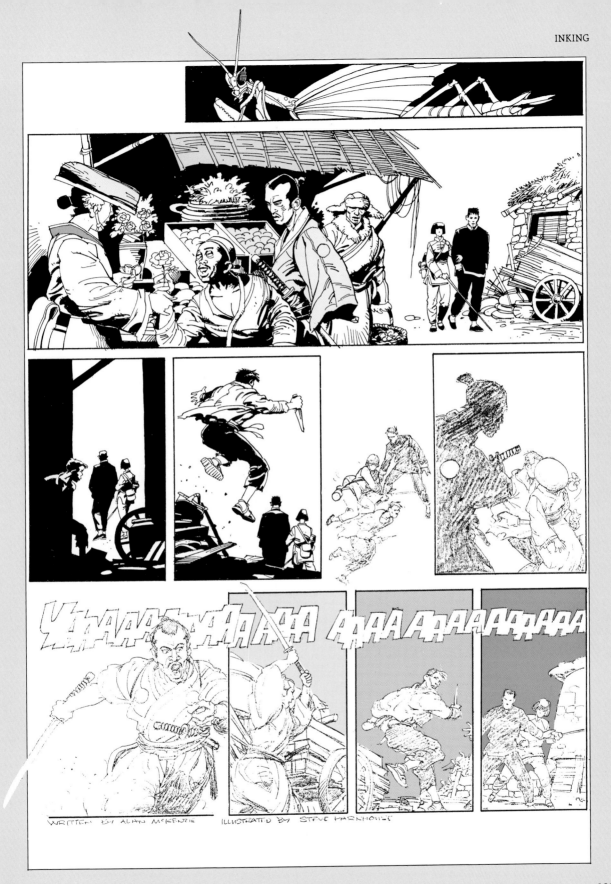

WRITTEN BY ALAN McKENZIE    ILLUSTRATED BY STEVE PARKHOUSE

# LeTTERiNg!

**Opposite:** Lettering is deceptively difficult to get right. It can make the difference between an appalling strip and one that positively shines.

The letterer's tools of the trade: a selection of dip pens; a fountain pen as favored by Will Eisner; an opaquing marker; a pot of process white for covering mistakes, and a lettering stencil, similar to the type used in the EC Comics of the 1950s. Stencil lettering is not used widely today and tends to give a very stiff, mechanical finish to a comic strip.

The lettering on a strip can sometimes mean the difference between make or break. Far too often, the lettering on comics is considered unimportant enough to be handled by just about anyone who happens to be handy at the time. Many novice artists submit to publishers samples that they have lettered themselves, and are then surprised when their efforts are rejected.

The simple fact is that some people can letter and some people cannot. Artistic talent has little to do with it. If you cannot letter then the best thing is either to leave lettering to the letterers or, if you are really determined, to *learn* to letter. All it takes is a little bit of know-how and a great deal of practice. In this chapter we shall look at ways to improve your lettering, with legibility as the prime consideration, examine the different lettering styles which have been used in comics over the years, and explain one of the most important aspects of lettering, the *placing* of the balloons and captions.

## Tools and techniques

Your choice of tools for lettering is far less important than in inking, but the same set of cautionary rules applies. Assuming we agree that no one would try to letter with a sable brush, that leaves us with dipping pens, stylograph pens, Pentel-type markers and – an additional choice – fountain pens: Will Eisner, creator of *The Spirit*, uses a fountain pen loaded with specially thinned India ink for his lettering (distilled water is the best thinning medium). When it comes to Pentel-type pens, bear in mind that the type of ink used in them is difficult to cover up with process white. This is a matter of some importance, because you are going to make more mistakes while lettering than in any other part of the comic-strip process.

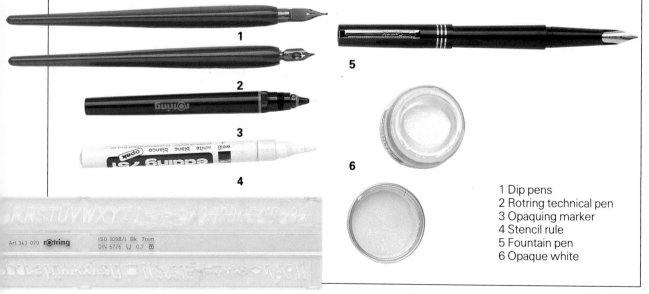

1 Dip pens
2 Rotring technical pen
3 Opaquing marker
4 Stencil rule
5 Fountain pen
6 Opaque white

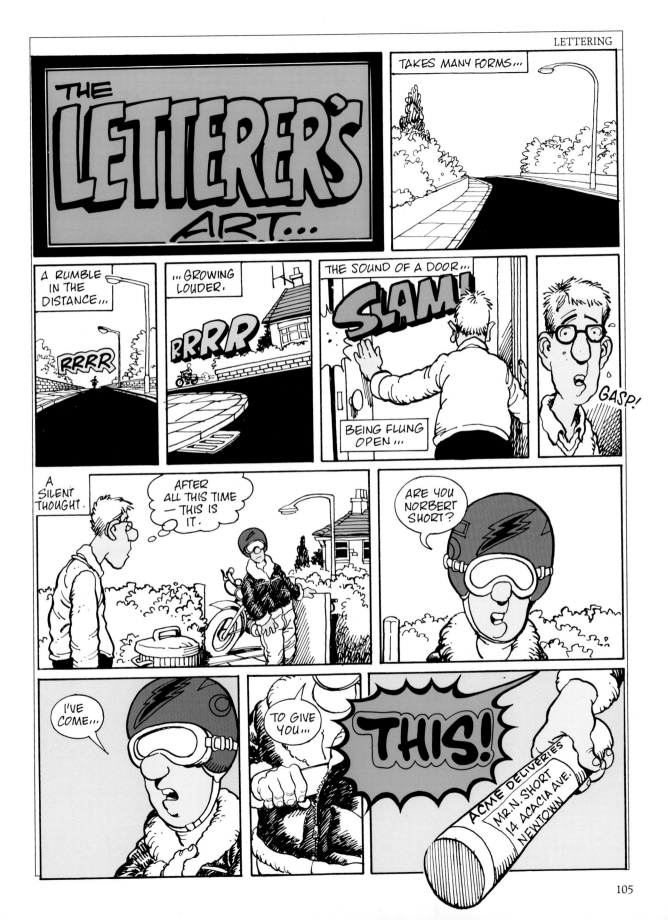

The letterer is responsible not just for straightforward lettering but for creating the balloons and the caption boxes. Stylograph pens really come into their own for this part of comic strips. The best speech balloons are drawn freehand, because freehand balloons have the same kind of spontaneity and dynamism that the actual artwork has. If absolutely necessary, you can use elliptical templates for making balloons, but this type of balloon is less desirable because it tends to look very mechanical when superimposed on freehand-inked artwork.

When it comes to the actual lettering, there are three distinct ways of going about it.

The easiest (but most expensive) is to have the lettering for your balloons and caption boxes *typeset*. For some reason, some editors and artists prefer this, although most comics editors will tell you that comic strip and typesetting do not mix. Typeset copy in comic strip is always in upper and lower case. *Mad* often uses this method, presumably to give the publication a more "adult" look. The only problem is that you have to know how to mark up type in order to convey your instructions to the typesetters. It may be possible to delegate this responsibility to your editor, but if you have to do it yourself you can probably get a lot of help from the typesetters who are doing the work. Even so, you should know the basics.

**Word balloons** can be drawn with a stencil, but look mechanical.

An "Ames" guide is a useful tool for drawing lettering guidelines.

Lettering guidelines should always be erased when the lettering is dry.

Balloons can be lettered on "Tik-Tak" patch paper and outlined freehand.

Balloons that are drawn freehand look more organic and easier on the eye.

A dab of process white clears a path for the word balloon's "tail".

The outline of the balloon tail is added when the process white is dry.

The final balloon has a most professional look!

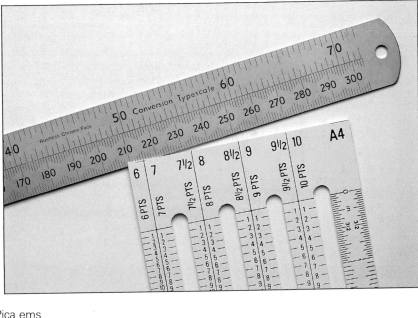

Two different kinds of tools for measuring typesetting: the metal version is usually called a typescale and is used to measure the width of type; the white plastic version is referred to as a depth scale, as it is normally used for counting lines of typeset copy. The main text of this book has been set to a measure of 27 pica ems.

Pica ems
0   6   12   18   24   27

Type-height is measured in "points," and a good readable size of type is about 10 point. (This book is set in 10-point type.) Remember, if you are planning to put typesetting onto the original artwork, which is presumably drawn half-up, you will need to have your text set in 15-point type.

Type-width is measured in "ems," sometimes called "picas." An em is one sixth of an inch. At any good art-supply shop you can buy rulers and typescales with em-scales printed on them.

Something else to bear in mind when setting balloon and caption text in type is that you have to mark it up so that it fits into the space available. The art of "casting off," so that text is set to fill a certain space, largely comes down to arithmetic. Any typesetter will supply you with examples of various sizes of type. From these it is a simple matter to count how many characters fit into any given space. It is mostly a matter of common sense.

Another method of lettering, called *LeRoy lettering*, although little used these days, involves a kind of template with an alphabet punched into it, all in capital letters. This system was used extensively in the great EC comics published by *Mad*'s William Gaines during the 1950s.

But by far the most popular of the three lettering methods is the simple *hand-lettering* system, also all in capitals. Hand lettering relies almost entirely on the steady hand and eagle-eye of the letterer.

Anybody can become a good letterer, provided they have at least average intelligence and are prepared to put in a lot of practice.

## Hand lettering
The first step in hand lettering is to lay down the guidelines between which the words will sit. This involves a T-square, a sharp HB pencil and either a little device called an *Ames guide* or a ruler. An Ames guide is a transparent plastic tool consisting of a movable dial with holes punched in it. The pencil point is placed in the appropriate hole of the Ames guide and then pencil and guide are drawn across the paper, using the T-square to keep the line straight. For drawing

guidelines on half-up artwork, the Ames guide should be set to about 3½, which gives guidelines about one seventh of an inch apart. The distance between the upper and lower guidelines will be larger than the gap between the lines of lettering, but the difference is left to the letterer. If an Ames guide is unavailable (I have never been able to find one outside the United States), then a regular ruler can be used to determine the distances between the lines. A good rule of thumb to remember for half-up artwork is about one seventh of an inch for the letter-height and about one twelfth of an inch for the gaps between the lines of lettering.

The guidelines are erased before the art is put under the camera. A letterer's most economical method is therefore to rule up sufficient guidelines for three or four lines of lettering right the way across the top of each tier of panels on a page, rather than to put the lines on each panel individually.

Guidelines drawn, you can get down to the nitty-gritty of lettering. The first rule of hand lettering is to be aware that you are drawing the letters individually, rather than writing down the words. This helps you avoid making typographical errors (called "typos" in publishing circles) and helps to make sure your letters are consistent. Thus the act of hand lettering is a good deal slower than the act of handwriting.

The next rule is that letters with round tops – i.e., C, G, O, Q, and S – *hang* on the upper guideline:

C G O Q S

Letters that contain horizontal strokes – A, E, F, H, L, T and Z – are drawn so that those horizontal strokes rise from left to right:

A E F H L T Z

The remaining letters in the alphabet likewise have their little peculiarities when hand lettered:

B D I J K M N
P R U V W X Y

a b c d e f g h i
j k l m n o p q r
s t u v w x y z.

Although lower case – or small – letters can be used for comic strips, the practice is unusual, mostly because the downstrokes of the y and g would interfere with the upstrokes of the d and b.

**Lettering on patch paper** First, letter the dialogue into the appropriate shape.

Draw a guideline in pencil so you know where to cut.

A smoother-cut line will be obtained with scissors rather than an X-acto knife.

Position the cut-out balloon on the panel in the correct position before pressing it down.

# ABCDEFGHIJKLM
ABCDEFGHIJKLMNOPQRSTUVWXYZ.

"Roman" is the term used to refer to upright lettering, which is used for the bulk of comic strip text.

# *ABCDEFGHIJKLM*
*ABCDEFGHIJKLMNOPQRSTUVWXYZ.*

"Italic" means that the lettering leans to one side — the right — and is used for emphasis or for caption boxes to distinguish them from speech balloons.

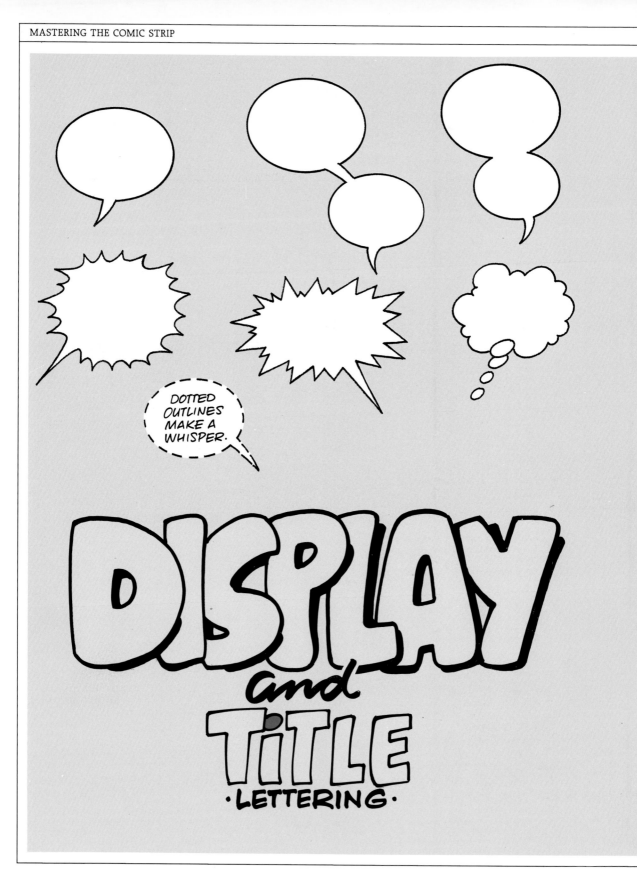

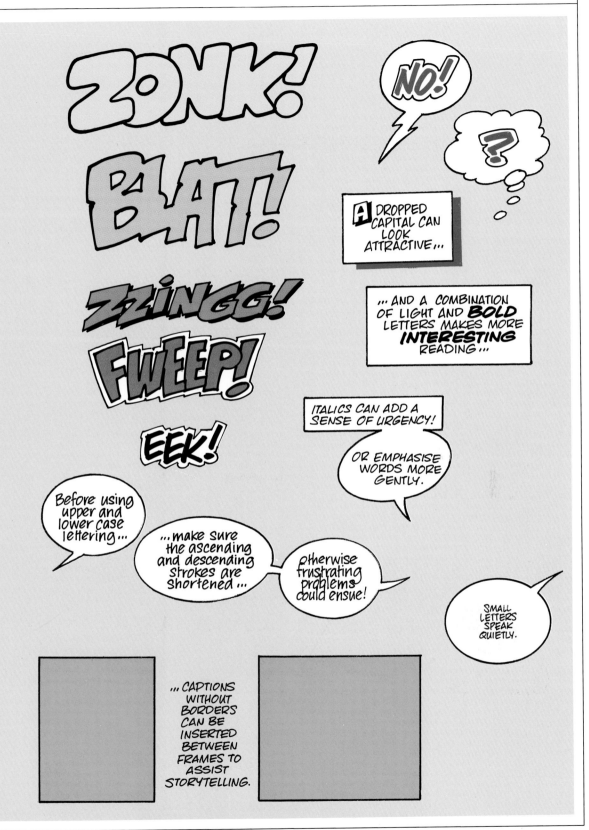

## All about balloons

When it comes to the balloon as a unit of lettering, there are several factors the letterer must consider. First, all balloons in a panel must be positioned not only so that no important portions of the artwork are obscured, but also so that the balloons read in the correct order, bearing in mind that the natural tendency is to read from left to right and from top to bottom. (You shouldn't have to worry about the positioning of caption boxes, as these are usually placed at the tops or bottoms of panels.)

You are bound by comic-strip convention to place a character's balloon as close to the speaker as possible. This eliminates confusion. If you are presented with a panel in which the character on the right is supposed to speak before the character on the left, you are in trouble. You could *try* putting the right-hand character's balloon above the left-hand character's head, and vice versa, and crossing the tails of the balloons over each other – but you'd never get away with it! In this situation, the only workable solution would be to have the whole panel redrawn. Of course, this is a hypothetical situation which should never arise in practice. But it might.

Another and more probable problem is that you may be asked to put more lettering into a panel than will comfortably fit there. This, of course, would be a result of either poor scripting – although *all* writers have a tendency to overwrite! – or poor editing. Short of cutting out some of the words, there is not much you can do – and cutting other people's copy is *not* the letterer's job and is definitely not advisable. However, sometimes a "wordy situation" can be alleviated by splitting one speech balloon or caption into two: that way you can make the best use of the available space.

The next thing to keep in mind is the *function* of the balloon. Most balloons will be for characters' dialogue, spoken at a normal conversational level. These are referred to as "speech balloons," for obvious reasons. Then there are balloons

**Below:** In *EC Comics,* the artwork was often subordinated to the lettering and, thus, the story.

**Bottom:** A daily strip from Alex Raymond's *Secret Agent X-9.* Note how the first person to speak in each frame is always placed to the left of the frame.

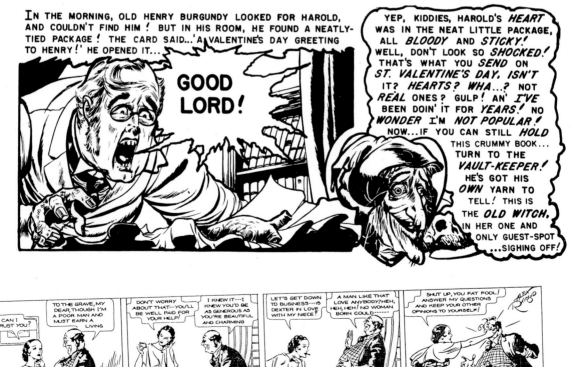

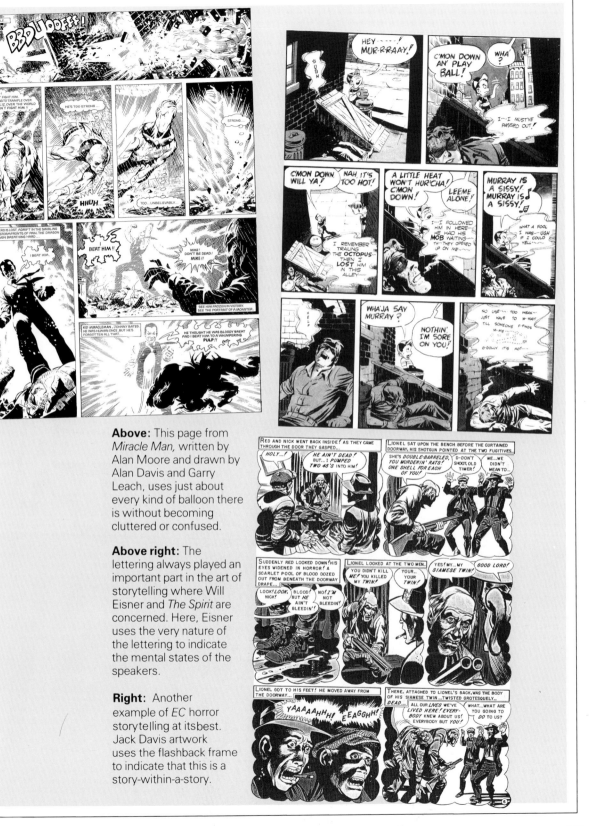

**Above:** This page from *Miracle Man,* written by Alan Moore and drawn by Alan Davis and Garry Leach, uses just about every kind of balloon there is without becoming cluttered or confused.

**Above right:** The lettering always played an important part in the art of storytelling where Will Eisner and *The Spirit* are concerned. Here, Eisner uses the very nature of the lettering to indicate the mental states of the speakers.

**Right:** Another example of *EC* horror storytelling at its best. Jack Davis artwork uses the flashback frame to indicate that this is a story-within-a-story.

designed to contain a character's thoughts. These resemble little clouds and are called "thought balloons." A type of speech balloon with a jagged border is used to indicate that the words are coming from a telephone, radio or some other electrical contrivance, but can also be used to show that a character is shouting. A reader must be able to tell the difference between these two applications of the same device by the context. Another way to show a character shouting is simply to letter his or her dialogue bigger. There are other variations on these themes. For example, if you wanted to indicate that a character was speaking in an icy tone you might show the lower edge of the speech balloon dripping with icicles. Of course, you can make up your own graphic devices and apply them where appropriate.

You can indicate a character's tone of voice or manner of speaking in the lettering itself. Walt Kelly, creator of the famous *Pogo* newspaper strip, used many different styles of lettering, sometimes within the same daily episode. Thus, an "Olde English" sort of script could indicate a character's old-fashioned nature, computer-style type could indicate the speech patterns of a robot, and so on.

All of the above assumes that you will be lettering directly onto the artwork, but this is not always possible. Sometimes, because of geography or any number of other factors, it is not feasible for the lettering to be put directly onto the art. In such cases, the balloons and captions can be lettered onto patch paper (a self adhesive paper called Tick-Tack is ideally suited to this) and then cut out and stuck down onto the artwork at a later stage. The only problem with this is that cutting around speech balloons with a scalpel is a laborious and boring process.

There are no rules as far as sound effects go. After all, who's to say whether "Scroommph" has one h or two?

Cutting around thought balloons is even worse. Jagged speech balloons are the worst of all. So this method is used only in emergencies – for example, when the job is running late and the lettering has to be done at the same time as the inking.

## Display lettering

"Display lettering" is the term used to describe the sort of lettering that is used in strips for sound effects and story titles as well as for the title logos of actual magazines. There are no particular rules about this area of lettering, and so studying examples of work by established professionals – there are plenty scattered around this book – will tell you more about the subject than any verbal instruction ever could. It should be mentioned, however, that if you plan to submit samples of artwork depicting an established character to a publishing company it is best not to try to include a hand-drawn version of that character's logo. Your version can only suffer by comparison with the original. Original logos for characters are drawn many times the size they will finally appear, and are reproduced photographically by the publishers when required. This means they have a perfection of finish you will never be able to achieve working only half-up.

### A reminder

The secret of a smooth lettering style is *practice*. The more you work at it, the better your lettering will become. So don't be disheartened if your first efforts are appalling. It can only get better from there ...

**Below:** Wally Wood made fun of the peculiar institution of comic book sound effects by telling a story entirely in lettering effects for *MAD* magazine.

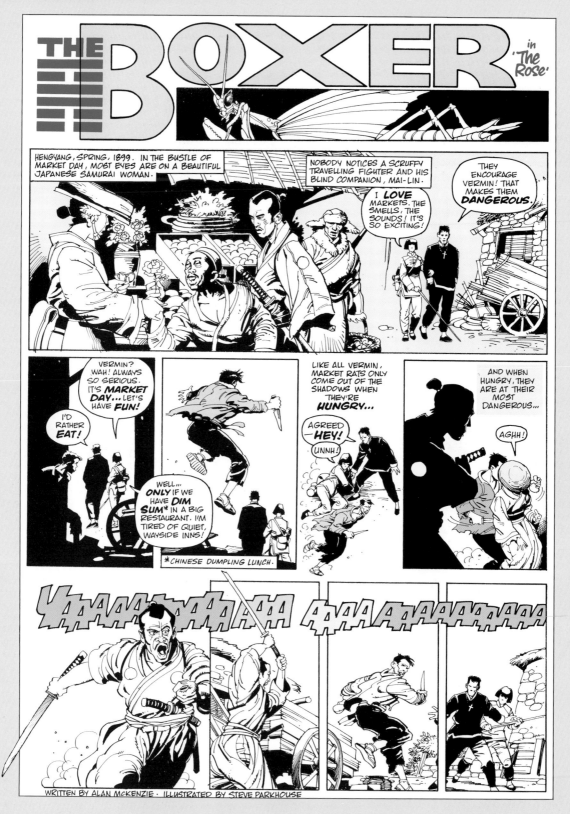

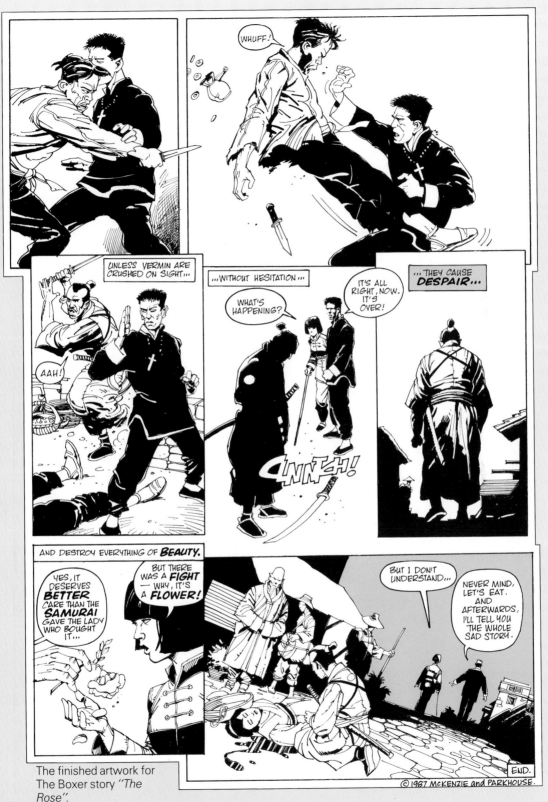

The finished artwork for The Boxer story "The Rose".

# PART 3 — SELLING YOUR WORK

# Getting Started

So you want to break into the world of comic strips. Well, the first thing you have to keep in the forefront of your mind is that editors are extremely busy people ... and, even if they are not, they *think* they are! This means that, if you send unsolicited artwork to an editor through the mail, he or she will put it at the bottom of the pending file and, within a week, lose it. This is why almost every magazine published carries a notice in it somewhere to the effect that the editorial staff can take no responsibility for unsolicited manuscripts, artwork or picture material. Editors give roughly the same attention to unsolicited material as you give to the junk mail that comes through your mailbox.

By far the best way to get editors to look at your artwork is to show it to them in person. It will not make them look any more favorably on your artistic efforts, but at least you will get an immediate answer.

The first thing you have to do is to be *very* sure that you are ready for the big time. Many of the editors I know complain that they are tired of looking at the artwork of would-be artists who clearly are not ready for professional work. Some even complain that they see too much artwork from "artists" who will *never* be ready! You should be able to tell by looking at your own work whether it is truly of a professional standard. If you have even the slightest suspicion that your efforts are not up to the mark, then spend another few months practising. If you need reassurance, ask a friend or relative for their opinion. Tell them not to be kind; you might help their objectivity by giving them some professional work against which to compare yours.

Now, assuming that your artwork looks good beside the best of the giants of the comic-strip business, you have to get an appointment to see the editor to whom you want to sell your material. It helps if you know his or her name. *Never* ring up a publishing company and ask to speak to "the guy in charge of *Nifty Adventures.*" First, ask the switchboard operator the name of the editor of *Nifty Adventures.* That established – we'll call our imaginary editor Ed Hackett – you

**Left:** To add a professional touch, have some business cards and letterheads printed up. This would indicate to the world that you're serious about your work!

can ask to speak to Mr. Hackett's secretary. Assuming the company is doing well enough to be able to afford a secretary for Mr. Hackett, you should make an appointment with the secretary to show Mr Hackett some artwork samples. If you fail to mention that these are *your* artwork samples, chances are the secretary will think you are an agent rather than a "hopeful" – or, even worse, a fan! This might sound deceitful, but it is no more misleading than editors telling themselves, or you, that they are busy.

So you have your appointment. What are you going to show this Hackett fellow? Well, do not show him some drawings you did "a few years ago." He is not going to be interested. He wants to see what you are doing *now*. And do not hand him artwork with an apologetic "this isn't very good" or "I can do better when my sprained wrist heals." No good. If it is not your best work, you should not be showing it to anyone. All that will get you is the door.

A brief aside. Paul Neary, an artist who worked for many years for the now-defunct Warren Publishing Group, which put out *Creepy*, *Eerie* and *Vampirella*, relates an illuminating anecdote. When a new artist met publisher Jim Warren for the first time to discuss their work, Warren would ask whether the artwork on the desk in front of them was the artist's best effort. If the hapless artist answered "No," Warren would get up and pull aside a small set of curtains on the wall behind him to reveal a sign which read: "We ARE the best!" And if the artist answered "Yes," Warren would bash a rubber stamp down on a sheet of paper and place it in front of the artist. The stamp read: "Bullshit!" Creative editing in action.

The point of this tale is that an editor wants to see only your very best work. And, if you are really serious about earning a living as a comic-strip artist, you will want *only* your very best work to be seen.

## Newspaper strips

There is very little market these days for the adventure strip in the newspaper arena, unless it features already-established characters from other media – like

**Above:** It is essential to have a portfolio for carrying around your artwork. Comic pages rolled up and stuffed in a plastic bag tend to arrive at their destinations more than a little dog-eared.

*Star Wars* – or it has itself been established as a newspaper strip for years or even decades – like *Steve Canyon*, *Modesty Blaise* or *Tarzan*. If it is adventure strips you want to do, pitch them at the comic-book publishers.

Which leaves, so far as newspapers are concerned, gag strips.

The point about gag strips is that the gag is everything. As Mort Walker, creator of *Beetle Bailey*, once pointed out, "The idea is the most important ingredient in a cartoon. A poor cartoonist with a great idea will succeed where a great artist with a poor idea will fail." In other words, as we saw in Chapter Four, there really are *no* techniques to be learned for drawing gag strips.

What a newspaper strip editor, or a syndicate editor, wants to see when you are submitting samples is finished examples of your strip idea. Six weeks, worth of strip is a suitable quantity. Certainly no more than that. If your idea is good enough, the editor should grasp it after reading five episodes. Even so, is advisable to draw up a "model sheet" of the regular characters you plan to include in the strip, along with short notes on their personalities, peculiarities and functions. But keep this brief. Remember, editors are under the impression they are very busy.

## Comic books

Most people, when they think of comic books, think of superheroes. This is a dated concept. Although superheroes are still the dominant force in the comic-book industry, their influence is dwindling. With the rise of the independent publishers in recent years, a more varied crop of comic genres is springing up.

Whatever the genre you are aiming for, the requirements for your "audition" with the editor remain much the same. Most editors want to see a page or two of penciled art, drawn to the same kind of format as the material they are already publishing. So check out one of the company's current publications to get an idea of how many panels to put on a page and the general shape of the page itself. You should include as part of your presentation a page or two of finished artwork, taken to ink stage but unlettered (although a sharp-eyed editor will spot whether you have had the presence of mind to leave "dead" space somewhere in every panel for speech balloons). The best mixture is to show one penciled and one inked page of one of the company's characters in action, and one penciled and one inked page of something of your own.

*Don't* try to impress the editor with a wildly original idea, concept or drawing style, especially if he is working for one of the big established companies. It is hard enough for long-time professionals to get original ideas into print, let alone beginners. The truth is that most editors do not *want* new ideas. They want old

**Right**: Ideally, your portfolio should contain a page or two of penciled artwork and a page or two of inked artwork. Try to include a strip based on your own ideas and a strip taken from the magazine whose editor you are trying to impress.

ideas dressed up to *look* new. If that sounds cynical, just remember that it is easier to change the establishment from the inside.

*Don't* overload your portfolio, or your target editor, with material. He or she will have made up their mind after seeing those first four pages. Anything more is inviting boredom.

*Don't* hang around for a chat afterward. Remember? – editors think they are busy people. Just get in, be polite, show your artwork, then get out.

And *don't* show an editor your artwork before you have reached an acceptable level of skill. Like a cat, you only have so many "lives." If you become known to an editor as a substandard artist, the label can stick.

## Pitching by mail

If you absolutely have to (and distance problems are the only excuse), you can submit your samples to the editor of your choice by mail. But be prepared for a long wait.

The first point in mailing submissions is *don't* send originals. If you do and they are lost, you're sunk. The responsibility is yours, by virtue of that little "no responsibility accepted" notice. Good-quality photostats will be quite acceptable for a preliminary submission. It might help to include tearsheets of your work from some kind of publication, even if it is a fanzine or amateur publication. The very fact that you have had work published, even in a nonprofessional capacity, will score you points with any editor.

Every piece you submit, even if it is only a photostat, should be clearly marked with your name, address and telephone number. This saves an editor rummaging through files trying to find a contact point for you when he or she rediscovers a piece of your work previously consigned to the "must return sometime" file and – on second thoughts – thinks it is brilliant.

You must include a covering letter with your submission. This should tell the editor a few relevant details about yourself. Your age will help the editor assess your progress as an artist and how much potential you may still have. You could mention that, while you have submitted samples of superhero art because that is what the editor's company publishes, you have a yen to draw a western strip. You never know, the editor might just be thinking of reviving the genre. But keep your letter brief and pertinent. No more than one side of an $8 \times 11$in sheet, preferably typed – or, if you really want to show off, hand-lettered.

Make sure your package is secure. There is no point in your samples arriving looking as if they have passed through a mincing machine on their way to the publisher's office: that would *not* inspire confidence about future transactions. At the same time, it should not be so "secure" that the poor editor cannot get the package open!

Always include a stamped, self-addressed envelope, big enough and with sufficient stamps on it to make sure your submissions can be returned. This won't *guarantee* you get them back, but it gives you a better chance. When mailing submissions to foreign countries, do not stamp your return envelope; instead, include International Reply Coupons – available at any good post office – in the package. Your post office will tell you how many International Reply Coupons you need to send.

Finally, it is a good idea to follow up your package with a phone call a week or so after you calculate the package should have arrived; you can say you are just checking to make sure your submissions got there. In reality, of course, you are jogging the editor's memory, reminding him or her that you are not going to be fobbed off too easily. If an editor pleads that he or she has had no time to look at your work, tell them you will call back in a week or so ... and then *make sure you do*. Eventually, the editor will look at your stuff and give you an answer one way or the other.

AND HERE'S A DRAWING OF **CAPTAIN MACKEREL** I DID WHEN I WAS *TEN*

### Right, might and copyright

An important point to bear in mind is that you should not go into the comic-strip business with the idea of becoming a millionaire. While it is true that a few – a very few – have amassed fortunes out of their creations, mostly on the newspaper side of the comic-strip business, there is generally nothing more than a comfortable living to be made out of comics. So it doesn't really pay to haggle about money with editors when you are first starting out. Remember that there are dozens of others trying to get into the business the same week as you, and *they* are not being pushy about money! No reputable company is going to rip you off, anyway – it simply would not be worth their while.

That said, it is worthwhile to pin down editors on exactly what they are buying for their (i.e., their company's) money. The history of comics is littered with stories of unfortunate creators who, little realizing the value of their creations, signed away all rights for a meal and a place to sleep. Incidents that spring to mind include the tale of Jerry Siegel and Joe Shuster, creators of *Superman*, who received any kind of royalties only recently and only after a long legal battle, and Jack Kirby, who co-created almost the entire Marvel Comics line of characters for the regular page rate.

In newspapers, most syndicates act as a kind of agency for your work. This is usually on a *sole* agency basis, with the syndicate getting 50 percent and you getting the other 50 percent. This applies wherever they sell your material, at home or abroad. You might be able to stipulate that the syndicate has the rights to sell only to newspapers or periodicals, thus keeping the potentially lucrative book rights for yourself. Alternatively, you could try to sell your strips directly to the newspapers, but this would be almost a full-time job in itself, and probably a poor money-maker.

The big established comic companies, like Marvel and DC Comics in the United States and IPC and D.C. Thomson in the United Kingdom, buy all rights to your work for the page rate. With the UK companies, you are paid once, they syndicate your work all over the world, and you see not another penny. With the big US companies, at least small reprint fees and token royalties are now being paid. But these payments are looked upon by the companies as bonuses, not as rightful royalties, and so they could be terminated at any moment at the discretion of the company bosses.

The smaller independent companies, like the US publishers First Comics and Comico, work on a basis which is closer to the syndicates' method. You are paid a page rate, then royalties on copies sold, then further payments are made if the art or characters generate money in other countries or in other media. The big problem here is that small comics companies often run into financial hot water, and even go out of business owing their freelancers small fortunes.

### The marketplace

The best way to see what is selling to editors in the various fields of comic-strip art is to examine what is currently being published. For newspaper strips, the only way in is usually the gag strip. And in the gag strip, many recent successes have displayed a surfeit of cuteness: *Peanuts* is cute, *Garfield* is cute, and their creators make many thousands of dollars out of the merchandising spin-offs of their characters. Cute seems to be selling. However, to a lesser extent, there is a market for cynicism, too. Strips like *The Wizard of Id* and *Doonesbury* come under this heading.

In comic books, there can be little doubt that the big sellers of the moment are books which feature teams of teenaged superheroes, such as Marvel's *X-Men* and DC Comics' *Teen Titans*. Also, comics created around toys seem to be doing well, notably *G.I. Joe* (called *Action Force* in the United Kingdom) and *Transformers*. So, if you can draw gigantic robots, you will be ahead of the pack.

However, the independent publishing companies, like Eclipse and Fantagraphics Books, are far more amenable to truly original ideas and unexploited genres. So if you absolutely *have* to produce a comic strip about tin mining or 1920s dance marathons, these would be the people to approach.

In the United Kingdom, the former best-selling comic, IPC's science-fiction comic *2000 AD*, is currently up for sale, which indicates that its fortunes have declined. The UK arm of Marvel Comics seems to be doing well with cute kiddy comics based on equally cute kiddy toys, notably *Care Bears*, although, at the time of writing, Marvel is just about to launch a comic based on *Thundercats*.

European publishers, like the US independents, are far more inclined to try new and different ideas, so, if you really want to be original, you might try France or Italy as a second choice.

*Love and Rockets* is a modern comics success story. Originally begun as an amateur publishing venture, *Love and Rockets* was picked up by Fantagraphics Books as a regular title and has since won just about every award going in the comics business. This page is from *Mechanics* by Jaime Hernandez.

# Keeping the Ball Rolling

**B**elieve it or not, but getting into the comics business is a good deal easier than staying in it. The first hurdle faced by a creator is to produce material (a) that an editor likes enough to publish and (b) to a deadline. This is made more difficult by the fact that every editor has his or her own beliefs about what makes good comics.

And comics eat up ideas at a frightening rate. In this chapter we shall attempt to show you how to maintain the flow of ideas, drawing inspiration from the unlikeliest of sources.

### Your first professional job

Supposing, after all your efforts, you get an assignment to draw a comic strip. It does not matter whether it is a newspaper strip for a comic book, you still have to deal with the mechanics of getting the job done before the deadline set by the editor. Sounds easy, right? Work late a couple of nights and the odd weekend and, presto, you are a comic-strip professional.

Forget it. *Nothing* is ever that easy.

The first hurdle you are likely to face is that you have to produce work that will please your editor. This is not an easy task. Many editors do not *know* what they like. Quite a few *think* they know what they like, but change their minds halfway through the job. A few talk loudly about what the public likes. This type of editor is dangerous and should be shot on sight. *No one* knows what the public likes.

The best editors are those who recognize good work when they see it and leave the writers and artists alone to get on and produce their best work.

The second hurdle is that your work has to please the public. As mentioned above, there is no way to second-guess your audience. There has never been a creator, in any artistic field, who has had the inside story on what the audience

**Below:** It is impossible to predict an audience. Bill Gaines, publisher of EC Comics, invented the horror comic almost by accident, more because he *liked* scary stories than because he thought they would sell.

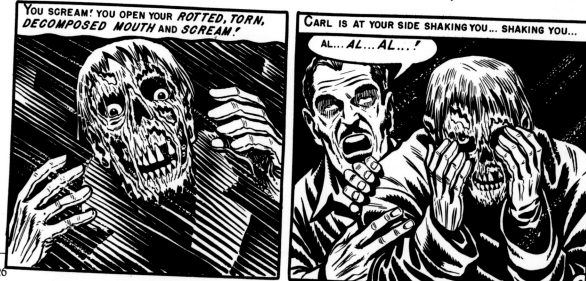

wants. It is often a matter of blind luck whether a comic strip catches on or not. All you can do is turn in your very best effort and keep your fingers crossed.

In order to produce your best effort, you need *time*. So do not agree to a ridiculously short deadline in order to impress your editor. While editors may be impressed when artists say they can produce 20 pages of art over the weekend, they are decidedly *less* than impressed when the work fails to materialize at the agreed time. Remember that along the line there is a whole chain of people – colorists, film-makers, printers – depending on your turning in your work when you say you will. Mess up your deadlines and your first professional job may well turn out to be your last.

It is very difficult to decide upon an average rate of work. With newspaper strips, the artists are usually writing their own material and writing cannot take place until inspiration hits. I have sat in front of my typewriter for *days* waiting to get an idea. Sometimes an idea comes, but sometimes it doesn't. All writers have in their files half-finished stories that will probably never have endings.

With comic books, artists are more likely to work from another person's script – at least at first. Very few artists begin in comic books by writing their own material as well. When working from another person's script, it is possible to get something down on paper without struggling for inspiration, even if the artist draws only what the writer has asked for and no more. The rate at which an artist gets the pictures down on paper varies from person to person and depends very much on the time available.

Assuming you are in full-time employment already, you have to accommodate your freelance assignments in your free time. Realistically, this will give you a maximum of four hours per evening and whatever time you can spare from eating, sleeping and necessary chores over weekends. If you are determined to create freelance while employed full-time, you may have to give up your social life for months – which is difficult, but not impossible.

Of course, one way to increase the time available for freelance assignments is to give up your daytime job. This is not a decision that should be rushed into. You should be working steadily in your spare time for at least six months before you seriously consider this bold move. The figure of six months is purely arbitrary, but a period of that order would give sufficient time to judge whether or not you would be able to secure enough work to pay all your bills and allow you to maintain or improve your existing standard of living.

An artist producing a newspaper strip for a syndicate has to produce six strips a week, regardless. Although some newspapers appear only five days a week, enough still put out a Saturday edition to make six strips necessary. A Sunday page would generally be optional, although the syndicate might insist on it.

Ultimately, a good rate of production for the comic-book artist to aim for is a page, penciled and inked, a day. Or two pages of pencils. Or two pages of inks. Keep up this rate and you should make enough money to live on. This means that you will be drawing about five pages of completely finished art a week, or 20 pages a month. Which just happens to be the rate at which the average UK and US comic book eats material.

It should be mentioned that there are comic-strip artists who produce material at far greater rates, and some who are slower. The speed at which newspaper-strip artists work has little bearing on how much they earn. Their income is dictated by how many newspapers subscribe to the strip. Only in comic books are the fastest workers rewarded.

## Scheduling your work

If you are working on your comic strips part-time, the question of scheduling hardly arises: you work whenever you have time – *any* time. But coping with the realities of full-time freelancing has proved the downfall of many young

hopefuls. There is a tremendous temptation to work late into the night and sleep it off the next day. While there is nothing actually *wrong* with this practice – doctors tell us that the 24-hour day is actually unnatural for most people – it is antisocial and leads eventually to a situation where the freelancer is working during the hours of darkness and sleeping during the day. This means that you are awake when everyone else is asleep, and vice versa, and so you lose contact with your friends, relatives and loved ones. This is not facetiousness; it has actually happened to people I know.

The most successful freelancers evolve a working habit not unlike a regular nine-to-fiver ... having breakfast, working, having lunch, working, having dinner, relaxing, going to sleep. Just like in real life. But it is not easy. It requires discipline.

An important point for freelancers concerns outside interests. Sitting all day and every day in front of an artboard or a typewriter can play havoc with your health and fitness. A couple of years of no exercise at all and any of us can be heading into heart-attack country. And freelancing can be a lonely business, especially if you live on your own. You just do not get the opportunity to meet people. I suggest you look around for a sport you can take up which requires the discipline of performing two or three times a week, and at set times. You can use your sport as a sort of clock by which to time your work periods; moreover, it ensures you have regular contact with other human beings. I opted for martial arts, but playing football or taking dancing classes would work just as well. Of course, you could go jogging every morning to keep fit, but it is advisable to select a sport in which other people are involved. Not only does this ensure that you actually do it – you cannot leave your partner or team in the lurch by not turning up – it makes sure that you do it *at set times*, and so have, as it were, an anchor on reality.

### Desperately seeking inspiration

Anyone in an artistic job has to deal with the difficulty of being creative on cue and to a deadline. There are no easy answers to this problem – in fact, there are no answers at all, really. But you might find it helped the flow of creative juices if you stuck to a regular schedule of work habits. It can help to have another project on the back boiler, which you work on when you find the going heavy on your main job. "A change is as good as a rest" might be a truism, but it is also true.

I find, as a writer creating visual ideas, that watching movies gives me a lot of usable notions. I am *not* suggesting you merely lift ideas and incorporate them into your stories or artwork, rather that you should use the images you see in other media as springboards for your own concepts. To give you an example, recently I was watching a spaghetti western film, *The Good, the Bad and the Ugly* (1966). There are a couple of scenes in which Clint Eastwood rescues Eli Wallach from the hangman by shooting through the rope. It occurred to me that the scene could be turned on its head, so that Eastwood shot Wallach before the hangman had a chance to execute him. Using this concept as a springboard, I wrote a story in which the Boxer (the star of our demonstration comic strip seen in its complete form on page 000 of this book) stops an execution so that he can himself execute a condemned prisoner – the man responsible for the death of his sister.

Admittedly, taking clichés and turning them inside out is an easy way of coming up with story concepts, but it is defensible where space is limited.

Real life can provide its share of inspirations, too. Joe Orlando, ex-EC artist and currently a senior editor at DC Comics, tells a story about the mid-1970s revival of the character The Spectre, a kind of costumed avenging spirit. "I had just been mugged in broad daylight on upper Broadway, where I was living at the time," remembers Orlando. "The feeling of helplessness and anger and loss of my manhood (my wife was with me at the time) as I watched the muggers strutting

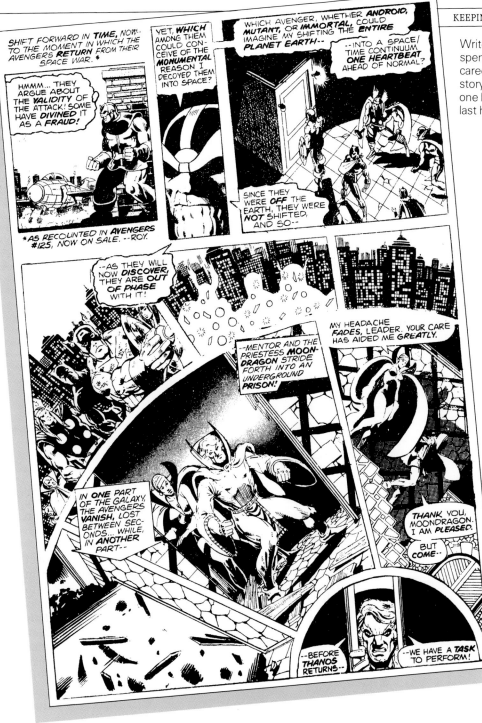

Writer/artist Jim Starlin spent most of his *Marvel* career telling one big story, in effect making one big complicated plot last him for years.

away with my wallet gave me the Walter Mitty idea of fantasy revenge. 'That's what I'll do to you bums, I'll bring back The Spectre. The Spectre will rid the world of evil vermin that preys on upstanding, hard-working, middle-aged comic-book editors.' From the reaction and sales on that book, I have a suspicion that a lot of muggers are reading The Spectre."

In short, the secret of inspiration is *input*: the more you put into your brain, the more you will get out of it.

# Starting Your Own Magazine

Selling your artwork or scripts to an established publisher is the commonest way of seeing your work in print. Yet, with the recent proliferation of specialist comic shops, in both the United States and the United Kingdom, it is becoming more and more feasible for comics creators to control their own work by publishing it themselves. In this chapter, we look at the nuts and bolts of preparing artwork for printing and discuss the most appropriate printing methods for a low-print-run magazine.

### Why publish it yourself?

A very good question. Publishing is a risky venture, especially when even people who have spent their entire careers in publishing admit to not knowing why one thing is commercial and another thing is not.

The problem with most existing publishing companies is that they are not interested in truly original ideas. As we have noted elsewhere, what they want are old and established ideas dressed up to *look* original. The problem with new ideas is that they have not been tested on the public before, and so a publisher has no way of knowing how audiences will respond. This is why so many comics publishers these days are keen to license well known properties and characters from other sources. Marvel's US operation publishes comics based on toys like Transformers and G.I. Joe. Marvel's UK office puts out comics based on Zoids and Care Bears. Even publishers like DC Comics and the UK's IPC Magazines, previously resistant to licensing deals, are publishing *Star Trek* and *Barbie*, respectively. Although this is a sure route to creative constipation, it makes clear commercial sense. So, if you have a truly original idea and you want to see it published without any kind of interference from well meaning editors or – worse – accountants-turned-publishers, your only path is to publish the material yourself.

This is not such a daunting prospect as it might at first appear, especially if you are prepared to forego profit and publish your comic on a non-money-making basis.

The first thing you need to do is to establish a format for your comic. For the purposes of amateur publications, with print-runs in the four-figure area, color is out of the question, except perhaps on the cover. And, unless you are an exceptionally talented artist with an exceptionally saleable idea, you would do best to keep your first print-run small. You can always reprint if you sell out overnight.

The most popular sizes for self-published efforts, referred to as *fanzines* (fan-magazines), are 5⅞in × 8¼in and 8in × 11in. The cheapest, and thus most popular, style of binding is saddle-stitching, in which sheets of paper are folded in half and stapled through the spine.

If we say that your hypothetical comic book will be 8 × 11in, with 32 black-and-white interior pages plus a full-color cover from your own mechanical separations, with a print-run of 1,000 copies, then you are looking at a print bill of somewhere around $1000. Don't be worried about asking several printers for

**A3**

16 · 14 · 12 · 10 · 8 · 6 · 4 · 2

17 · 19 · 21 · 23 · 25 · 27 · 29 · 31

COVER

**Left:** This is how the pages of a magazine fit together. For small print jobs, money can be saved if you paste the pages together in the order shown. **Right:** Staples through the spine of a magazine is known as ''saddle-stitching''.

**Left:** The original colour artwork.

Yellow

**Above:** The separate primary color components that make up a four-color print job. **Right:** Each color is printed on top of the last — yellow first, then magenta (red), cyan (blue) and finally, black.

Magenta

Cyan

Black

Yellow + magenta

Yellow + magenta + cyan

Yellow + magenta + cyan + black

quotations – it costs nothing to ask! It is up to you what you charge for individual copies of your comic but keep in mind the spending power of your market.

The only way to print such a magazine economically is with the sheet-fed litho process. Commercial magazines are printed on web-offset printing machines which feed paper to the printing plates from a huge roll of paper – a bit like a giant toilet roll. This method is feasible only for large print-runs because it prints so quickly. If you were to try to print a 1000-copy run on a web machine, you would have to stop the printer almost before you started it!

With the sheet-fed litho process, the method used by all print shops, your 8 × 11in magazine would be printed on 16in × 11in which would then be folded in half for stapling. Thus, leaving aside the cover, which would probably be printed on different paper from the rest of the magazine, the first sheet printed would have pages 32 and 1 on one side with 2 and 31 on the other. The next sheet would have 30 and 3 on one side with 4 and 29 on the other, and so on. Your magazine would be made up of 9 16 × 11in sheets in total – 8 for the insides plus one for the cover – folded in half to make 36 pages, including the cover.

### The artwork

You have to make sure your artwork is drawn to the correct proportions. Drawing artwork larger than the printed size allows the printer to reduce the artwork, so that your drawing looks more detailed and professional. (Tips on drawing for reduction are included in the chapter on inking – see page 000.)

Let us assume, still, that you want your magazine's format to be 8in × 11in. Remembering to allow for a border of white space around the area actually covered by artwork, perhaps your best bet would be to draw on board which is exactly half-up from 8 × 11in – i.e.— 16 × 11in. If you leave a one-inch border

**Right:** *The Comics Journal,* an American ''fanzine'', combines in-depth analysis of the comics world with hard-hitting criticism and probing interviews to make the best magazine of its kind available.

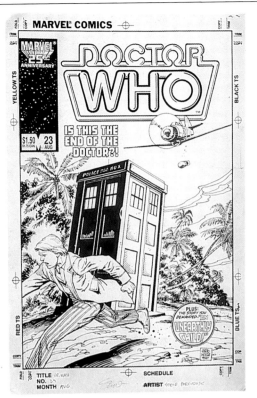

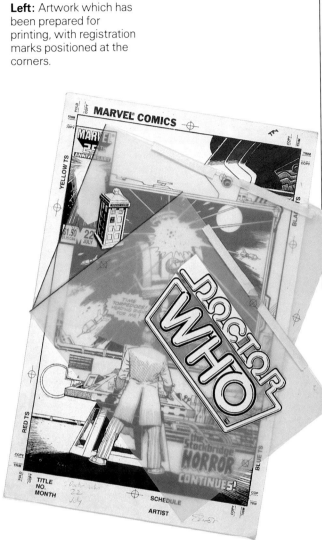

**Left:** Artwork which has been prepared for printing, with registration marks positioned at the corners.

**Right:** Lettering will often be printed in colors other than black. This effect is achieved by pasting the lettering down on acetate overlays, each equipped with registration marks, so that the printer can easily line up the components for the final printing.

between the edge of your artwork and the edge of the board you are drawing on, the printed comic will have a border of two-thirds of an inch between the edge of the artwork and the edge of the page. In printing jargon, the area covered by the artwork on the printed page is called the "type-area." Where artwork runs off the edge of the page – which should happen only when you want it that way! – the effect is called "running to bleed." However, this is difficult with the sheet-fed litho process and is best avoided in such print jobs.

You should take care that your artwork pages are numbered clearly so that the printer gets them in the right order in the finished magazine. There is no use complaining after the magazine is printed. Printers seldom admit liability for mistakes, even where it *is* their fault. They are much less likely to when really the fault was yours for not giving them clear instructions.

### Color separations
There are two methods available of preparing artwork for printing in color. Both require the making of color film, from which the printing plates are made. There are four sheets of film at the end of the process, one for each of the four colors

**Right:** Preparing your
artwork for color printing
must be done with care.

1 Board
2 Clear acetate
3 Opaque white
4 Paint brush
5 Sharp knife
6 Letratone: 25%; 50%;
   75%

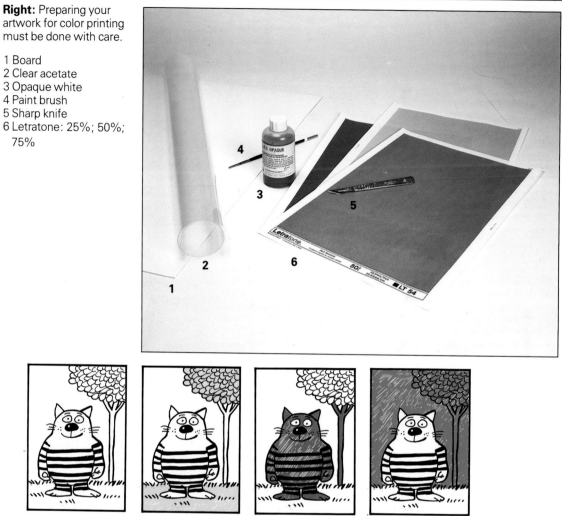

The artwork you have
drawn is half-up but you
may want to make
reduced copies on a
photocopying machine for
color roughs.

Yellow rough    Magenta rough    Cyan rough

commonly used in color printing: these are yellow, cyan (blue), magenta (red)
and black. From each of these sheets of film a printing plate is made. The paper is
passed through the printing machine four times, once for each color. Every color
you see in a printed comic book can be produced using a combination of these
four.

The easiest – but most expensive – method of four-color film-making for the
artist is photographic separation. In this, full-color artwork is placed under the
printer's camera and photographed four times through four different colored
filters. The resulting four films are used to make the necessary printing plates.
This process would cost you somewhere in the region of $300 for the film of just
one page.

A cheaper alternative is to produce mechanical separations yourself. This
involves breaking down the required colors into their component constituents
by hand, and is the method used by most comic-book publishers the world over.

The first step in this process is to obtain a quantity of acetate sheets, some
sheets of self-adhesive mechanical tones (Zipatone or Letratone would be
perfect) in various values (I recommend 25 percent, 50 percent and 75 percent at
80 lines per inch; the assistant in the art-supply store will know what you are

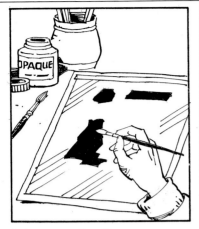

**Color separation** The acetate is laid over the line artwork and the appropriate areas blocked in with printers opaque fluid.

Where percentages of primary colors are required, a mechanical tint is laid down.

The mechanical tint is trimmed into shape with an X-acto knife and the excess peeled away from the acetate.

Yellow

Magenta

Cyan

When all three primary acetate separations are combined with the line artwork, true four-color is achieved.

The three process colors that, together with black, are used for color printing.

talking about when you ask for these!), and a pot of printers' opaquing fluid. All of these items can be bought from most art-supply stores.

The next step is to draw the black part of your cover artwork and have this reduced to the size it will appear in print. This is best done by having a Photo-Mechanical Transfer (PMT) made. Making a PMT is a simple process in which line artwork can be reduced or enlarged onto photographic paper. Your local print shop should be able to do this for you, or direct you to someone else who can. Then you have to mount the PMT of your artwork onto a larger piece of white board. Next you must draw registration marks at the corners of the artwork to indicate where the trim line is; the trim line is where the magazine will be trimmed by the printers – i.e., cut along its open three edges.

This accomplished, you take three appropriately sized acetate sheets and draw registration marks which correspond exactly with those on your mounted PMT. This is to enable the printer to register all four colors – the three acetates and the flat black line artwork – together during printing.

Now you are ready to begin the task of making your separations. First, though, a useful extra step is to have some photocopies made of your mounted cover and to color these appropriately with felt markers. This makes it easier when it

**Above** Tint charts are essential for full-color work. They enable you to tell the printer exactly what color you want by quoting the percentage of yellow, magenta and cyan must be used.

When two halftone screens are superimposed at the wrong angle, a moiré effect occurs. This problem can be corrected by repositioning the screens. Similarly, when making your tint overlays it is essential that you experiment by twisting the tints before you cut them to size to avoid a moiré effect occurring.

comes to breaking down the colors you want on your cover into their constituent ingredients.

Next, attach your mounted cover PMT to a firm surface, such as your desk, with masking tape at the corners. Position the first acetate sheet over the PMT, lining up the two sets of registration marks and taping the acetate in place. You are now ready to begin the *real* work.

It is normal practice to make the yellow film first: take care that you mark the sheet "yellow" for the benefit of the printer. With a brush and opaque fluid, paint on the acetate sheet over all the areas you want to end up yellow on the printed cover. You repeat the process on the other two acetate sheets, representing the other two colors (your PMT will be used for the black film). That takes care of the primary colors.

The next step is to consider the secondary colors – that is, all the colors made up of two primary constituents. This is where the mechanical tones come into play. For example, light green might be made up of 25 percent blue and 100 percent ("solid") yellow. So, to get light green, you reposition the "yellow" film

over the cover and paint in all the relevant areas with printers' opaque; then you substitute the "blue" acetate and cover all those areas with a 25 percent mechanical tone. Thus, when the two sheets are combined at the printers, the result is light green. You repeat variations on this process for the rest of the secondary colors. Tertiary colors are those which require three constituent primaries, but the technique is essentially the same.

At this level of printing, mechanical color separation is largely a matter of intuition and luck. It is possible to obtain printed sheets which show you examples of each combination of primary colors, but these are notoriously unreliable. The best advice is to keep the coloring simple. The more basic the color separation the less chance there is of anything going wrong.

If you have any problems with any of the above, a friendly printer who wants your business might be persuaded to help out.

A final tip. When laying tones on top of tones, each successive layer should be rotated through 45 degrees before being stuck down to avoid producing a moiré pattern. A moiré pattern, when mechanical tones are superimposed on the printed page, gives the optical illusion of shimmering forms. The phenomenon is often called "screen clash."

## Distribution

Assuming you get your magazine printed without mishap, the next big problem you face is getting the copies of it out to an eager public. One way is to sell it direct by mail order. This way you do not have to give wholesale discount to retailers or distributors, and can therefore sell your product at a lower cover price. An ad in one of the many comic fanzines might bring good results. You can find a few useful addresses in the Appendix.

But, if you do not want to be bothered with mailing out 1,000 copies (if you're lucky!) of your comic, you could try wholesaling it to specialist comic distributors, a selection of which is also given in the Appendix. This entails giving a discount of at least a third off your expected cover price but, well, there is no such thing as a free lunch! Certainly, you are saving yourself a lot of work selling your magazine this way.

Making the potential audience for your comic aware of its existence is a vital step in marketing your product, and so review copies should be sent out to the various existing fanzines. Once again, relevant addresses are to be found in the Appendix.

And, if all else fails, you always have 1,000 copies of a magazine to burn to keep you warm over the coming winter.

# Useful names and addresses

Here are some useful addresses for the aspiring comics creator, including comics publishers, comic fanzines and specialist comics distributors. Space is not available to list specialist comic shops – of which there are many – but most of these advertise in the comic fanzines listed below.

## NORTH AMERICA

### Publishing houses

Comico, The Comic Company
1547 DeKalb Street
Norristown
PA 19401

DC Comics Inc.
666 Fifth Avenue
New York, NY 10103

Eclipse Comics
PO Box 199
Guerneville
CA 95446

Fantagraphics Books
4359 Cornell Road
Agoura
CA 91301

First Comics
1014 Davis Street
Evanston
IL 60201

Gladstone Publishing Ltd
PO Box 2206
Scottsdale
AZ 85252

Kitchen Sink Press Inc.
2 Swamp Road
Princeton
WI 54968

Marvel Comics Group
387 Park Avenue South
New York, NY 10016

Capital City Distributors
2827 Perry Street
Madison
WI 53713

Glenwood Distributors
124 Vandalia
Collinsville
IL 62234

Styx Comics Service
1858 Arlington Street
Winnipeg
Manitoba, R2X 1W6
Canada

Superhero Enterprises
70 Morris Street
Morristown
NJ 07960

### Comic fanzines

*Comics Interview*
Fictioneer Books Ltd
234 Fifth Avenue
Suite 301-G
New York, NY 10001

*The Comics Journal*
4359 Cornell Road
Agoura
CA 91301

### Specialist comics distributors

Andromeda Publications Ltd
367 Queen Street West
Toronto  Ontario, M5V 24A
Canada

Bud Plant Inc.
PO Box 1886
Grass Valley
CA 95945

Cowles Syndicate Inc.
715 Locust Street
Des Moines
IA 50304

Los Angeles Times Syndicate
218 Spring Street
Los Angeles
CA 90012

News America Syndicate
1703 Kaiser Avenue
Irvine
CA 92714

Tribune Media Services Inc.
64 East Concord Street
Orlando
FL 32801

King Features Syndicate, Inc.
235 East 45th Street
New York
NY 10017

**SYNDICATES**
Adventure Feature Syndicate
329 Harvey Drive
Suite 400
Glendale
CA 91206

Cartoonists & Writers Syndicate
67 Riverside Drive
New York
NY 10024

Chronicle Features
870 Market Street
San Francisco
CA 94102

Renegade Press
4201 W. Alameda #20
Burbank
CA 91505

# UNITED KINGDOM

**Publishing houses**
D.C. Thomson & Co., Ltd
185 Fleet Street
London EC4A 2HS

Harrier Comics
33 Chester Road
Northwood
Middlesex HA6 1BG

IPC Magazines Ltd
King's Reach Tower
Stamford Street
London SE1 9LS

Marvel Comics Ltd
23 Redan Place
London W2 4SA

**Comic fanzines**
*Fantasy Advertiser*
25 Cornleaze
Withywood
Bristol BS13 7SG

*Speakeasy*
Acme Press
PO Box 617
London SW4 0HU

**Specialist comics distributor**
Titan Distributors Ltd
PO Box 250
London E3 4RT

# Bibliography

In learning to draw comics there are two distinct stages: first, you must learn how to draw; second, you must learn how to draw *comics*. Obviously this book is concerned with the second stage. In case you need help in learning how to draw, however, I have included a short selection of books that will tell you how best to go about developing your basic drawing skills.

**General books**
*Artist's Market*, Writer's Digest Books, Published September every year
Cole, Rex: *Perspective for Artists*, Dover Books, New York and London, 1971
Hogarth, Burne: *Drawing the Human Head*, Watson-Guptill Publications, New York, 1971
Dodson, Bert: *Keys to Drawing*, North Light Books, Cincinnati, 1985
Hogarth, Burne: *Dynamic Anatomy*, Watson-Guptill Publications, New York, 1971
Hogarth, Burne: *Dynamic Figure Drawing*, Watson-Guptill Publications, New York, 1971
Presnall, Terry: *Illustration & Drawing: Styles & Techniques*, North Light Books, Cincinnati, 1987
Prince Davis, Sally: *Graphic Artist's Guide to Marketing & Self Promotion*, North Light Books, Cincinnati, 1987
Thompson, Ross & Hewison, Bill: *How to Draw and Sell Cartoons*, North Light Books, Cincinnati, 1985

**Other books on drawing comics**
Eisner, Will: *Comics and Sequential Art*, Tamarac (Florida), Poorhouse Press, 1984
Lee, Stan, and Buscema, John: *How to Draw Comics the Marvel Way*, New York, Simon and Schuster, 1978; London, Titan Books, 1986

# Acknowledgements

Despite what it says on the cover, no book is ever produced entirely by one person. And this book is no exception.

So special thanks to Steve Parkhouse, who produced a lot of artwork in a short space of time for this book, not least of which was the art for our special demonstration comic strip, and who also contributed valuable technical data. Thanks to Win Wiacek of Winning Streak, who researched most of the US comic-book pages we have reproduced. I'd like also to thank Dez Skinn, my first boss in the comics business, who generously donated comic-strip material from his classic publication *House of Hammer* free of charge.

I want to thank Quarto senior editor Polly Powell, who didn't bat too much of an eyelid when I told her the manuscript was going to be over a week late.

Then there are the various comics professionals I've worked with over the years who have contributed to this book, whether they realize it or not. So a tip of the hat is due to Paul Neary, Steve Moore, Dave Gibbons, Richard Burton, Alan Moore, David Lloyd, Steve Dillon, Annie Halfacree, Ellita Fell and Alan Murray.

And finally, very special thanks to Lorraine Dickey, without whom I'd probably never have written this book.

Alan McKenzie
London, 1987

# Index

Page numbers in *italic* refer to illustrations.